de Kooning

drawings / sculptures

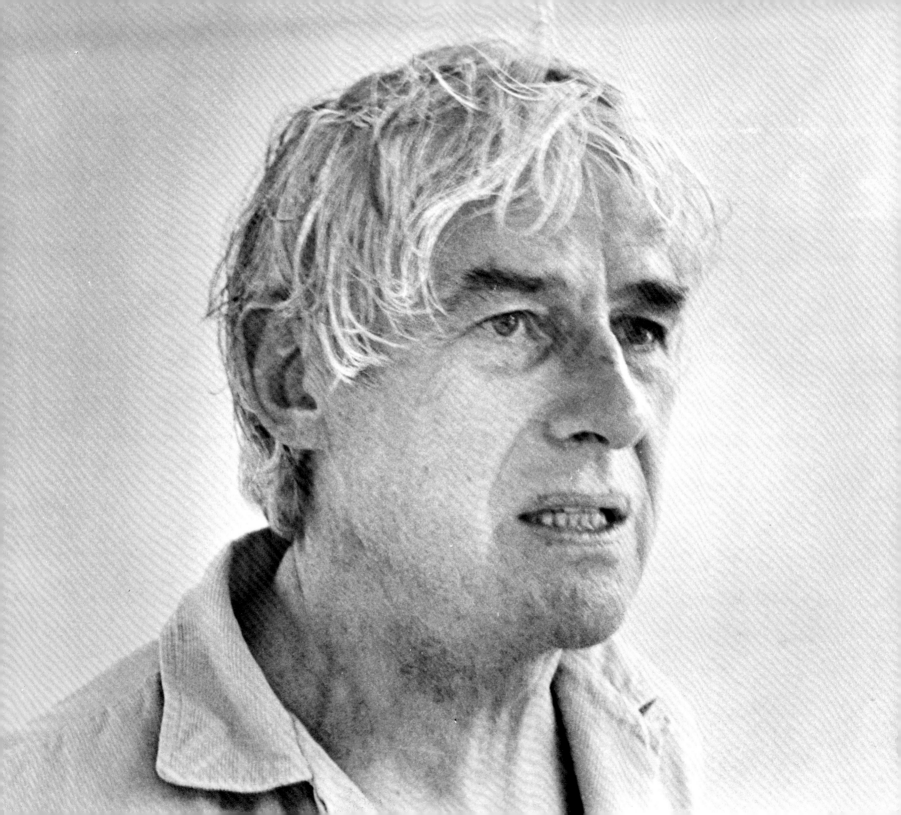

de Kooning

drawings/sculptures

by Philip Larson and Peter Schjeldahl

an exhibition organized by Walker Art Center

Walker Art Center, Minneapolis
March 10 - April 21, 1974

The National Gallery of Canada, Ottawa
June 7 - July 21, 1974

The Phillips Collection, Washington, D. C.
September 14 - October 27, 1974

Albright-Knox Art Gallery, Buffalo, New York
December 3, 1974 - January 19, 1975

The Museum of Fine Arts, Houston
February 21 - April 6, 1975

E. P. Dutton & Co., Inc., New York, 1974

The exhibition is supported by a grant from the National Endowment for the Arts, a Federal agency, Washington, D.C.

Lenders to the Exhibition

Allen Memorial Art Museum, Oberlin College,
 Oberlin, Ohio
Mr. and Mrs. Julius E. Davis, Minneapolis
Mr. and Mrs. John C. Denman, Bellevue, Washington
Mr. and Mrs. Lee V. Eastman, New York
Fourcade, Droll Inc., New York
Mr. and Mrs. B. H. Friedman, New York
Hirshhorn Museum and Sculpture Garden,
 Smithsonian Institution, Washington, D. C.
Sidney Janis Gallery, New York
Willem de Kooning, Easthampton, New York
Dr. and Mrs. Samuel Mandel, Kings Point, New York
Munson-Williams-Proctor Institute, Utica, New York
Musee Nationale d'Art Moderne, Paris
The National Gallery of Canada, Ottawa
Mr. and Mrs. Stephen D. Paine, Boston
Tamara Jane Safford, Freeport, New York
Mr. and Mrs. Robert C. Scull, New York
Mr. and Mrs. Sherman H. Starr,
 Lexington, Massachusetts
Allan Stone Gallery, New York
Mr. and Mrs. George L. Sturman, Chicago
Mr. and Mrs. Paul Tishman, New York
William Zierler, New York

Anonymous loans from private collections

Published simultaneously in Canada by Clarke,
Irwin & Company Limited, Toronto and Vancouver.

Library of Congress Catalog Card No. 74-76241

ISBN 0-525-47376-9

Acknowledgments

We have come to regard a painter's drawings as an intimate aspect of his production, an informative revelation of his creative development. In such drawings, germinal forms materialize, frequently to be elaborated upon and extended in subsequent paintings. However, in Willem de Kooning's case, separation between the drawing and painting processes is virtually non-existent since drawing, whether on a fine, compressed scale or in expansive athletic gestures, is the core of his art. This exhibition focuses on this core, and further illuminates his attitudes about contour, mass and gesture by presenting a group of his recent sculptures.

From de Kooning's own collection, we have been able to borrow an important group of works—drawings that document the evolution of his long, productive career. These constitute impressive cycles of stylistic development. We are grateful to the artist for supplying these works and most of all, for his interest and assistance in preparing our extensive exhibition.

Many collectors, museums and dealers permitted Walker Art Center to borrow drawings in pencil, ink and pastel for this occasion. Xavier Fourcade, long a friend of de Kooning and now a major New York representative of the artist, was consistently supportive of the exhibition; not only did he help us secure significant loans of drawings but the Fourcade, Droll Inc. gallery enabled the Art Center to show the complete range of de Kooning's sculpture.

Philip Larson, Curator at Walker Art Center, worked closely with the artist on many aspects of preparing the exhibition and wrote the catalogue essay on the drawings. Poet and critic Peter Schjeldahl wrote the perceptive article on de Kooning's sculpture which appears in the catalogue. Thomas Hess, a close friend of the artist and author of a new book on de Kooning's drawings, published by Paul Bianchini last year, gave valuable counsel during the organization of this exhibition.

Many members of Walker Art Center's staff worked on the exhibition. Gwen Lerner, assisted by Lynda Hartman, handled registrarial details. James E. Johnson, with the assistance of Wayne Henrikson, designed the catalogue; Mildred S. Friedman assisted in its editing and Margie McKhann prepared the biographical and bibliographical sections. Peter Georgas and Mary Hooper were responsible for public information. Pamela Barclay, Joan Benson and Linda Erickson provided secretarial assistance and Eric Sutherland made several color photographs for this catalogue. Eldor Johnson, Stuart Nielsen, Douglas Caulk, Ron Elliott, Terry Fischer and Meridith Dotzenrod installed the exhibition.

Martin Friedman
Director
Walker Art Center

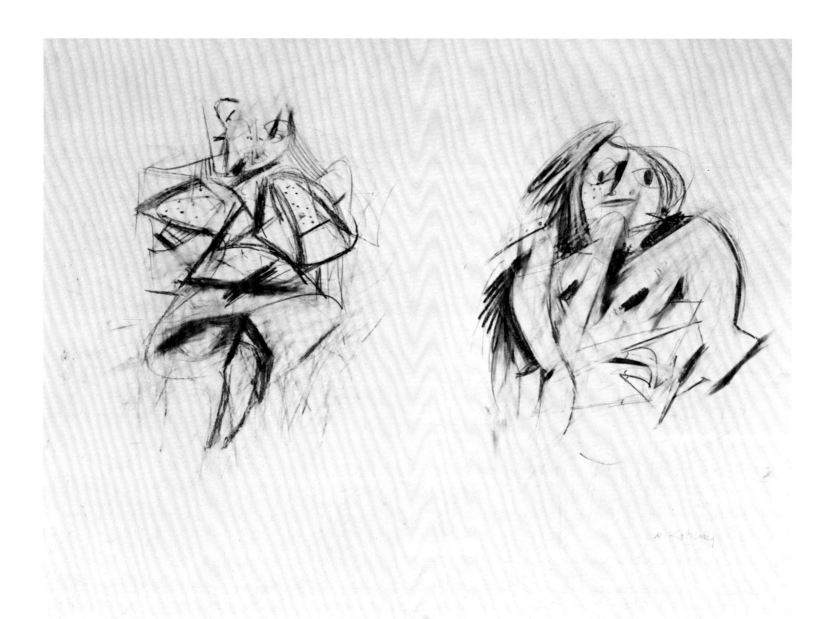

1 Woman Studies 1953 cat no 75
Private collection, courtesy Fourcade, Droll Inc., New York

De Kooning's Drawings

by Philip Larson

Too long eclipsed by his dramatic oil paintings, de Kooning's vast production of pencil sketches, pen drawings, pastels and works in charcoal must now be regarded as a major graphic achievement. The drawings in this exhibition document nearly every phase of de Kooning's long career, from the precisely contoured early figure studies to his recent involvement with nearly structureless form. His figurative pastels, particularly the "woman" series of 1951-52, are unique in mid-century modernist art, and place him at the side of such great European draftsmen as Picasso and Matisse. His black and white ink drawings record his constant struggle to eliminate traditional barriers between drawing and painting procedures; they constitute the artist's most radical contribution to abstract art.

A vanguard figure in the late 1940s, de Kooning's presence dominated painting and drawing for an entire decade. His attitudes toward picture making left an indelible imprint on two generations of American artists. Now 70 years old, he is one of the few first-generation survivors of the legendary group of New York artists who wrested American painting from its long apprenticeship to European styles.

Since the late 1930s, cycles of abstraction have appeared in de Kooning's drawings, yet a force has periodically drawn him back to expressionist figuration. For some thirty-five years the "woman" image—standing, seated, shown in pairs or in landscape settings—has been the recurring *idee fixe* of his art. De Kooning's "woman" drawings, which reflect an intimate side of his temperament and echo his conservative European artistic training (he moved from his native Holland to America in 1926), are as reliable an indication of his creative thought processes as are his large works in oil. The sketches reveal a fine sensibility not widely appreciated outside a small collectors' circle, yet this extensive body of work is unmatched among his generation of Abstract Expressionists. Franz Kline's calligraphic marks on telephone pages and Jackson Pollock's turbulent "psychological" drawings were germinal, but subordinate to the artists' highly developed paintings. Among de Kooning's friends, only Arshile Gorky seemed to regard drawing as an indispensable, every-day activity—but even he considered drawing the servant of painting.

Drawing was always central to de Kooning's art. During the late 1930s and early 1940s he laid out his large compositions with generalized contours. His sketches for the New York World's Fair mural project of 1937 are among the few extant works from these formative years. In a sequence of anatomical studies, he focused on details of hands, heads and strongly muscled torsos. These analytical sheets reveal an intense preoccupation with the single figure, the subject that was to dominate his mature work. At first, in such sketches, he isolated and elaborated on elements of the body in an effort to discover underlying abstract form. While there are many such sketches from the early 1940s, few drawings and pastels seem to have survived from the highly productive period of experimentation, 1945 to 1950, when de Kooning made his definitive break from the academic nude. One might logically conclude that numerous preliminary studies were required to effect this radical change—and they were—but most of the sketches were literally embedded in the paintings; they exist in collage fragments under roughly applied layers of paint.

In the late 1940s de Kooning considered drawings to be essentially "warm-up" probing exercises for painting in oils. He began with charcoal drawings on paper, which were then torn and juxtaposed with fragments of other drawings and oil sketches. These composites were adhered to canvas and, thus, preliminary sketches became the visible history of the painting. The unitary drawing, independent of painting, reemerged in de Kooning's work around 1950. Imagistically, these were basically spin-offs from previous paintings. Executed in ink or black enamel on paper, these crucial drawings were variations on the quasi-anatomical forms outlined in his Abstract Expressionist oils. Some of the enamel drawings are characterized by dripped paint in loose, curvilinear forms; others are improvisations on inter-locking Cubist forms.

These painterly, abstract sketches were succeeded in 1951 and 1952 by a long series of radiant pastels and

charcoal drawings which document de Kooning's abrupt return to the female figure. Obsessively detailed, the pastels are miniature versions of his spectral "woman" paintings of the same period. These "woman" images gradually gave way to a second cycle of abstractions, represented in this exhibition by several pastels and large brush drawings from the late 1950s. Another series of "woman" sketches followed in the 1960s, typically involving pairs of women—voluptuous figures in confectionary landscapes filled with sprawling plants. Sketches de Kooning made in Charleston, North Carolina and Spoleto, Italy in 1969, the most recent group in this exhibition, are vignettes of bar and cafe life, casual subjects only nominally apparent in the recent oil paintings.

I

De Kooning's artistic training in Holland was thoroughly conventional and, in itself, hardly prepared him to strike out into uncharted territory. After attending the Rotterdam Academy of Fine Arts and Techniques, he worked in commercial art but was dissatisfied and left Holland for New York in 1926. Although he had seen some modern French painting, and was generally aware of the abstract experiments of the Dutch *de Stijl* group, this background provided him with little more than a means for making a living in New York. For years he supported himself as a house painter, worked on store window displays and, on occasion, painted portraits. Only in 1936 did de Kooning decide to join the ranks of the "fine" artists, when he signed up for the mural painting division of the W.P.A.

His most important commission under the Federal Arts Project was a large mural for the Hall of Pharmacy in the 1937 New York World's Fair. The earliest drawings in this exhibition are studies for its design, later enlarged mechanically and painted by assistants. Although the 96 foot long mural no longer exists, photographs (fig. 2) indicate it was one of the most ambitious projects of the W.P.A. Formally, it was an effort to reconcile his conflicting commitments to the human figure and to abstract form. The drawings (fig. 3) contain mechanical contraptions of uncertain origin (are they the monitoring gauges in an operating room, van de Graf generators in a laboratory?) which are transformed into eccentric geometric shapes. Biomorphic forms suggesting animal

2 *Design for New York World's Fair Mural "Medicine"* 1937
Present location unknown

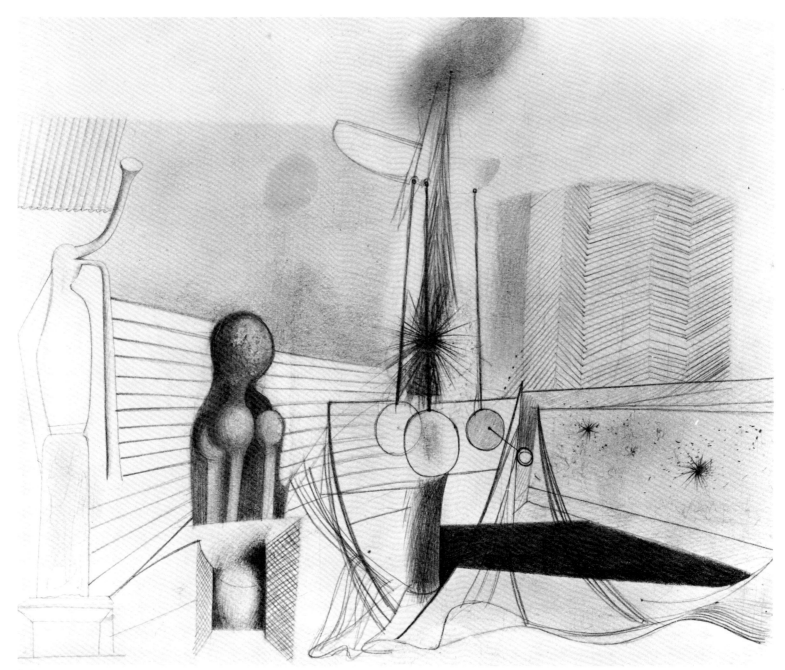

3 *Study for World's Fair Mural "Medicine"* 1937 cat no 1
Courtesy Allan Stone Gallery, New York

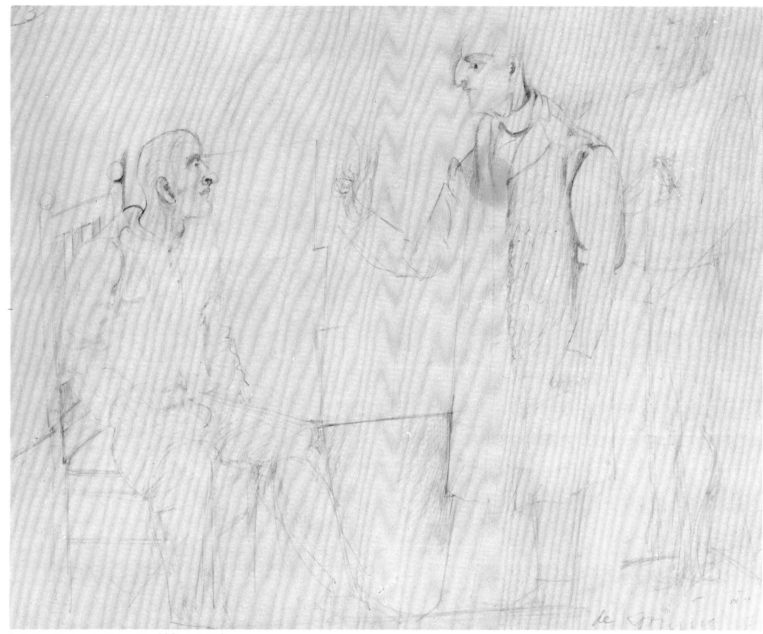

4 Three Studies of Men ca 1938 cat no 9
Courtesy Fourcade, Droll Inc., New York

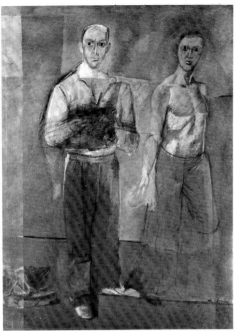

5 *Two Men Standing* ca 1938
Private collection

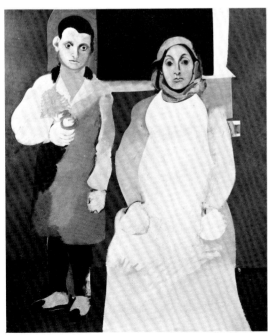

6 Arshile Gorky *The Artist and His Mother* 1926-29
Collection Whitney Museum of American Art, New York

and plant life exist within a network of intersecting lines. Here de Kooning's synthesis of the mechanical-architectural with the animal-human, so central to Surrealist ideology of the 1930 s into the paintings of the Chilean Surrealist painter Matta, yields a virtual catalogue of images that would pervade his later work.

Around 1940, de Kooning found himself hedged in on all sides by masters he fiercely admired but was reluctant to imitate. He was impressed by Picasso's expressionistic figurative style, Boccioni's manipulation of compressed space, and Miro's animated evocation of a fantasy world. But, these artists seemed simul-taneously to invent and exhaust an idiom, and Mondrian's geometric compositions, in de Kooning's own words, "had nothing left over" for the next generation. Even European Surrealist painting, brought to prominence in New York by the exhibition *Fantastic Art, Dada and Surrealism,* at The Museum of Modern Art in 1936, interested de Kooning more for its intuitive attitudes toward art than for its highly polished, literal style.

A contemplative mood permeates de Kooning's realist drawings and paintings of the 1940s. Most of these are studies of seated figures in interiors (fig. *4*). Some pencil sketches reveal the artist himself, stripped to the waist, gazing passively into space; others focus closely on details—the nose, biceps, ears; his variations on these elements imply movement toward his unique form of anatomical abstraction. The most "finished" of these drawings relate closely to his paintings that contain single figures seen against architectural arrangements, a formalized portraiture scheme standard in Western art since the Renaissance. During this period de Kooning also worked in a studied classical mode in a series of drawings of himself and friends (fig. *35*). Faint and exquisite as old master silverpoints, these studies reflect his academic training. Their refined style and tranquility is reminiscent of drawn portraits by the early 19th century classicist Ingres and his German contemporaries in the *Lukasbrueder* guild.

The most intriguing of de Kooning's contemplative figure drawings position puppet-like people in a surreal, "metaphysical" space (fig. *36*). The wooden mannequin, armature for window display or adjustable model for life-drawing classes, had been elevated to thematic

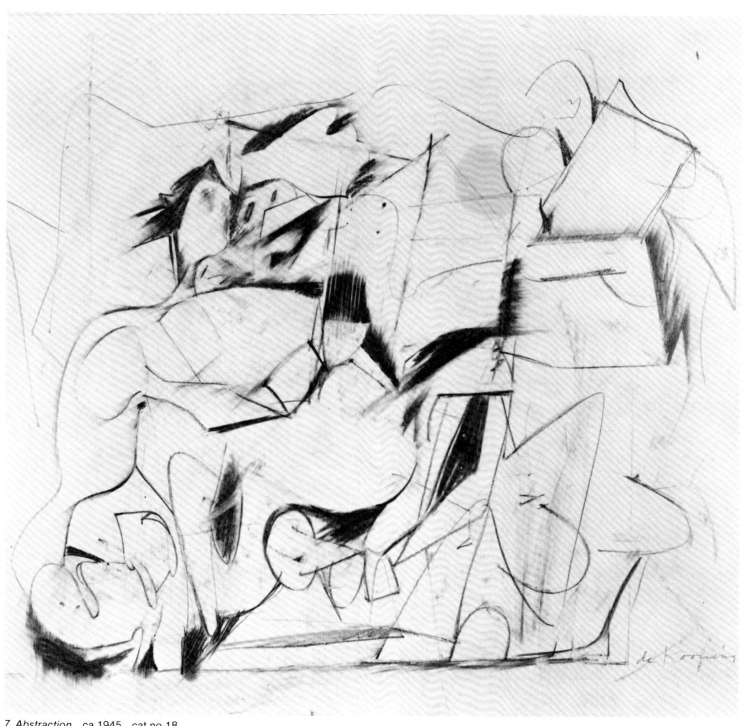

7 Abstraction ca 1945 cat no 18
 Collection Mr. and Mrs. Lee Eastman, New York

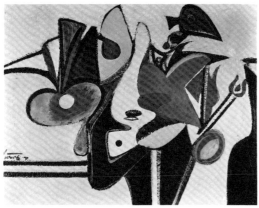

8 Arshile Gorky *Painting* 1936-37
Collection Whitney Museum of American Art, New York

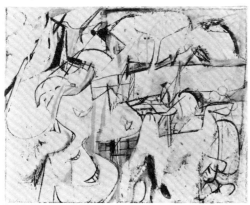

9 *Mailbox* 1947
Collection Mrs. John Pillsbury, Crystal Bay, Minnesota

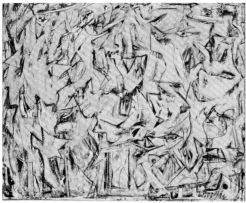

10 *Excavation* 1950
Collection The Art Institute of Chicago

status earlier in the century by the proto-surrealist Giorgio de Chirico and the Bauhaus painter Oscar Schlemmer. Both emphasized the mechanistic quality of the mannequin, treating it as a mysterious robot; de Kooning did the opposite by giving it a strangely subdued life. In his compositions mannequins stand or gesture ceremoniously, as if motivated by some inner spiritual resource.

De Kooning approached organic abstraction through his exploration of diverse figurative styles. This quest was largely the result of his friendship with Arshile Gorky, whose studio he shared in the late 1930s. The Armenian born painter, like de Kooning, based his early style on an intense study of new French painting. De Kooning's 1940s figurative drawings rework Picasso's classic style—but it was Picasso seen through the eyes of Gorky. De Kooning's seated and standing wide-eyed figures, located in generalized interiors, have self-engrossed expressions and are defined by contours evocative of Gorky's "Picassoesque" works (fig. 6). Both Gorky and de Kooning were equally interested in Miro's fluid universe of semi-abstract personages—Gorky's art began with a conscious absorption of elements from Miro—and, like Miro, de Kooning wanted to reconstitute the human figure from separate, fantasized components. In de Kooning's mid-1940s work, human references occur, but the overall configuration is abstract. Bone, tendon and joints are symbolized by abstract shapes and connectives. Like Miro, he often reduced figurative shapes to closed, smooth contoured biomorphs, common denominators of form within the figure.

II

De Kooning's pastels and charcoals from the later 1940s, while reflecting Gorky's syncretistic tendency to combine Cubist structure with biomorphic form (fig. 8), begin to break away from underlying European influences. In *Abstraction,* a work from 1945 (fig. 7), organic shapes, vaguely alluding to plant and animal life, cluster in the center of a composition whose background functions as a table top or tilted floor. As de Kooning radically divided flat spaces into tightly packed puzzle pieces, object shapes become interchangeable with background shapes. Organized as a Cubist still life, *Abstraction's* flattened, contradictory

spaces indicate his progress toward non-objective art. Forms set up surface tensions that extend from the center to all sides of the composition. The figure, windows, floor and table are now inextricably embedded in the faceted surface; every element locks into place.

De Kooning's drawings of the mid-1940s hover between figuration and abstraction: the recognizable fragments of human forms invite a poetic or dramatic interpretation, yet all such attempts are bound to fail. As in a Bartok quartet, significance lies not in recognizing a familiar tune, but in comprehending the overall harmonic sense. The point may seem academic, but there has been considerable debate over just how abstract, that is, just how radical the pioneer abstractionists in America were. Rothko's paintings are seen as sky-filled landscape, Clyfford Still's pictures as primal mountain formations, Mondrian's "Boogie Woogie" compositions as New York street plans, de Kooning's pictures as seething orgies—about the only lesson to be learned from such discussions is that Abstract Expressionist works may look like a variety of things, but these are still not what they are "about." The subject matter of de Kooning's semi-abstractions, then, should probably be construed broadly, as a generalized battlefield of life forces.

Critics have long assumed that de Kooning's Abstract Expressionist work deals with images of sex and violence, partly because of the continuing influence of Surrealist thought which emphasized Freudian qualities in the visual world and in the art making processes. The shifting images in de Kooning's work have been read as participants in dramas of sexual tension and release, an interpretation apparently buttressed by the unquestioned eroticism of his earlier, more literal work. Also underlying this view was the assumption that de Kooning and his Abstract Expressionist friends were sorcerers or high priests, wrestling with elemental forces. Though this seems rather melodramatic in retrospect, there remains a powerfully subjective element in de Kooning's work that cannot be explained away by formal means.

At the crux of de Kooning's Abstract Expressionist style is the intimate relationship of his drawings to his vigorous oils of the late 1940s. Among the most celebrated of these is *Mailbox* of 1947 (fig. 9) and

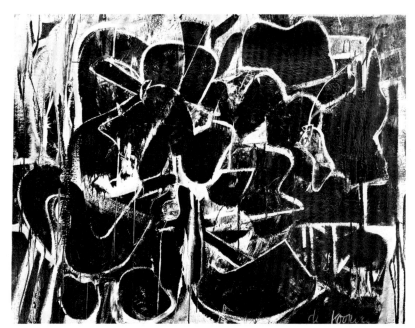

11 *Painting* 1948
Collection The Museum of Modern Art, New York

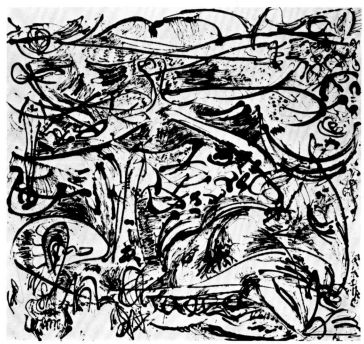

12 Jackson Pollock *Echo* 1951
Collection The Museum of Modern Art, New York

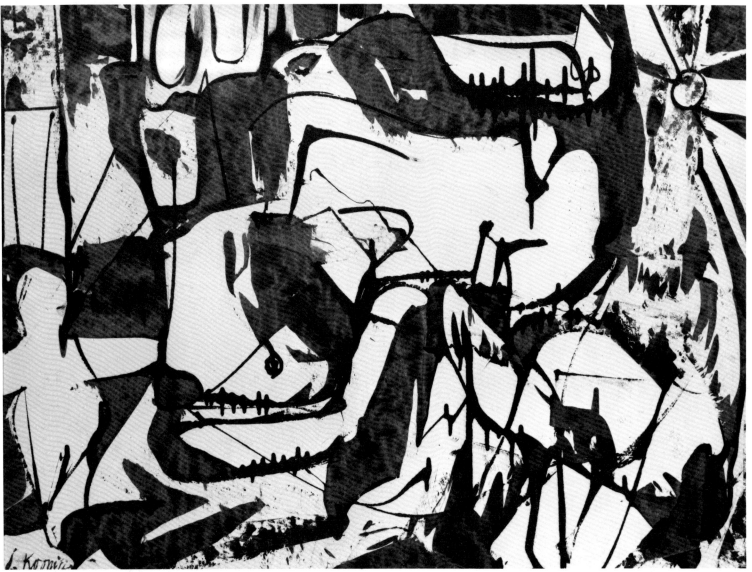

13 *Untitled (Black and White Abstraction)* 1950 cat no 32
Collection William Zierler, New York

Excavation (fig. *10*), finished in 1950. In these "drawn" paintings, de Kooning developed the procedure of overpainting layers, literally sheets, of drawings in oils. By drawing with charcoal over the paint surface, he integrated drawing and painting into a single activity. He also incorporated tracings; typically, parts of an unresolved work were traced on paper and shifted around on the painting surface until the composition was resolved. Sometimes de Kooning traced sections about to be painted out, salvaging them for later work. Used once and discarded, these tracings were like the overpainted sketches in that they existed solely as a source for something else. De Kooning's paintings became a function of drawing, and drawing procedures still influence the way he paints. (Drawing and painting, still isolated in traditional art curriculums, continue today to be segregated into "linear" and "painterly" opposites by Hegelian-minded art historians. Implicitly, de Kooning's art refutes such exclusive distinctions— the drawings are painted, the paintings are drawn.)

The reciprocity between de Kooning's painting and drawing is illustrated in this exhibition by a selection of black enamel drawings dating from the late 1940s to 1951, usually titled *Black and White Abstraction* (fig. *13*). In some of these, de Kooning dripped enamel in long, tenuous lines; in others, he scrubbed paint with a brush or applied it with a palette knife. The drawings follow a famous series of black paintings (fig. *11*) and, on first encounter, appear to be "negative" variations on these. But the enamel drawings are complete compositions in themselves, and form a tightly coherent body of work.

De Kooning's *Black and White Abstraction* series unavoidably brings to mind the work of one of his closest friends, Jackson Pollock. Pollock's drip paintings on paper precede those of de Kooning by about two years and his black-white paintings, such as *Echo* of 1951 (fig. *12*) extend through the period when de Kooning was drawing with the same Sapolin enamel. He was impressed by the raw physical energy of Pollock's work, but his own work did not parallel Pollock's characteristic atomization of form; rather, he wanted to present rough-hewn, vitalistic images. Pollock's drip method, above all his emphasis on body-size gesture, helped de Kooning loosen his attachment to Cubist collage. De Kooning had applied

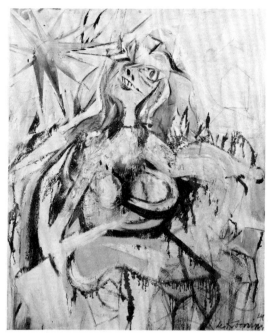

14 *Queen of Hearts* 1943-46
Collection Hirshhorn Museum and Sculpture Garden,
Smithsonian Institution, Washington, D. C.

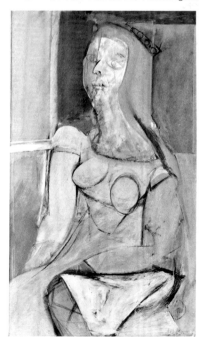

15 *Woman* 1948
Collection Hirshhorn Museum and Sculpture Garden,
Smithsonian Institution, Washington, D. C.

dripped edges to his black-white paintings of the late 1940s, but images in these were still composed piecemeal. Pollock's more expansive approach encouraged de Kooning to work toward a faster, more unitary surface image, that is, one that is drawn, not constructed.

At several critical junctures, de Kooning has, like his friends Pollock and Kline, resorted to the poverty of black and white. The first most important period was in the late 1940s, when he gradually abandoned complex color for monochromatic grays. The black enamel drawings coincide with Kline's first black-white paintings of 1949-50, and represent a parallel pursuit of strong, elementary form. The *Black and White Abstraction* drawings indicate de Kooning's decided shift from his delineating, contouring drawing style, derived in large part from Gorky and the Europeans, to the evolving gestural tradition in New York.

The active, decentralized images in the *Black and White Abstraction* series subverts traditional "figure-ground" relationships. Black brush strokes alternately define underlying white shapes and thicken as shapes themselves. These shapes create an alive, churning surface on which black and white forms resonate as functions of each other. This emphasis on energized, tactile surfaces, also evident in de Kooning's drip paintings (fig. *11*), is a crucial aspect of his art.

De Kooning's work and that of the other Abstract Expressionists invited intense speculation at the time it was being created. Theories were advanced by a few New York critics who frequented the artists' studios and witnessed works in progress. Harold Rosenberg voiced one of the earliest, most influential interpretations in the December 1952 issue of *Art News:*

> At a certain moment the canvas began to appear to one American painter after another as an arena in which to act—rather than as space in which to reproduce, redesign, analyze or "express" an object, actual or imagined. What was to go on the canvas was not a picture but an event.

Art-making as "event" was a theoretical construct appropriate for large, often wildly athletic paintings, but this generalization did not, at the time, do justice to

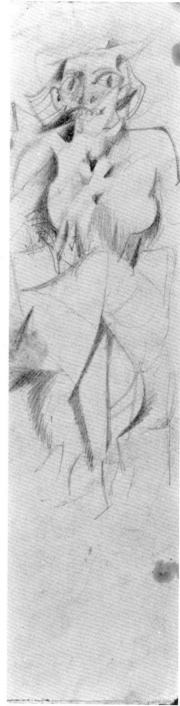

17 Woman 1950 cat no 37
Private collection, courtesy
Fourcade, Droll Inc., New York

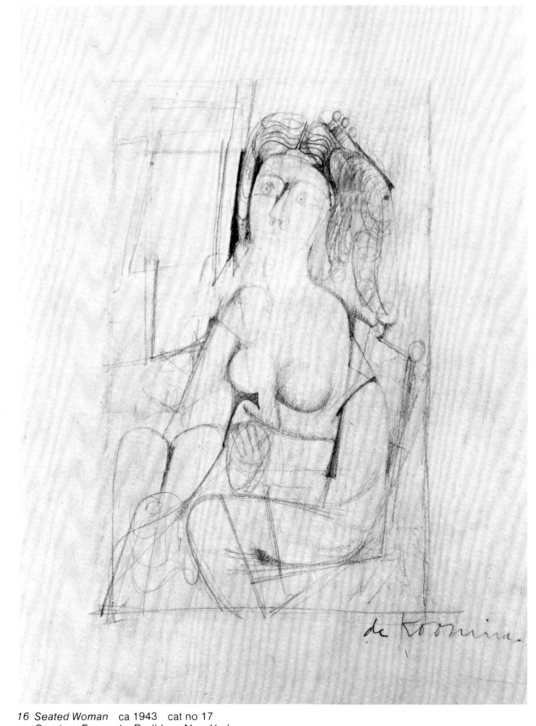

16 *Seated Woman* ca 1943 cat no 17
Courtesy Fourcade, Droll Inc., New York

20th century allegorical portraits of circus performers and royalty, by Picasso, Roualt and Beckmann. These artists painted human types representing modern day Everyman or universal aspects of the human psyche. De Kooning's post-1950 women are demonic creatures, whose heavy breasts and provocative poses suggest a more animalistic type appropriate to his rough, expressionist drawing style (fig. *21*). These ferocious females originate from the "aggressive" woman—the prostitute, faded fashion queen, pinup model or movie starlet. Garish color photographs of such types, often torn from magazines and tacked casually to the studio wall, were frequently the artist's point of departure. He improvised on the forms, colors and costumes, freely associating body parts with surrounding material. In the resulting, highly charged compositions, the subject can be described best in compound terms, as "woman-image," "body-form" or "female-landscape."

In a 1960 interview with David Sylvester of the BBC, de Kooning talked about struggling with the "woman" images:

> The *Women* had to do with the female painted through all the ages, all those idols, and maybe I was stuck to a certain extent; I couldn't go on. It did one thing for me: it eliminated composition, arrangement, relationships, light—all this silly talk about line, color and form—because that was the thing I wanted to get hold of, I put it in the center of the canvas because there was no reason to put it a bit on the side.
> So I thought I might as well stick to the idea that it's got two eyes, a nose and mouth and neck. I got to the anatomy and I felt myself almost getting flustered. I could never get hold of it. It almost petered out. I never could complete it and when I think of it now, it wasn't such a bright idea. But I don't think artists have particularly bright ideas. Matisse's *Woman in a Red Blouse*—what an idea that is! Or the Cubists—when you think about it now, it is so silly to look at an object from many angles. Constructivism—open, not closed. It's very silly. It's good that they got those ideas because it was enough to make some of them great artists.

De Kooning's "woman" drawings only superficially document his life outside the studio. The more important record is one of artistic process and decision making, subsequent to outlining the figure on the paper. Like the head in classical portraiture or the fruit in a

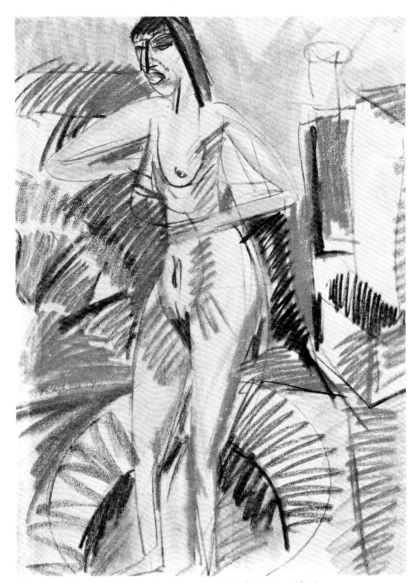

20 Ernst Ludwig Kirchner *Standing Nude in Bathtub* 1914
Collection Mrs. Ala Story, Santa Barbara

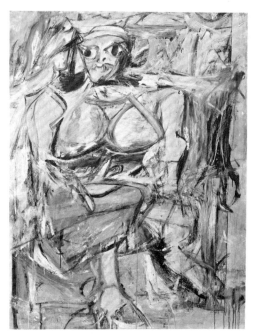

18 Woman I 1950-52
Collection The Museum of Modern Art, New York

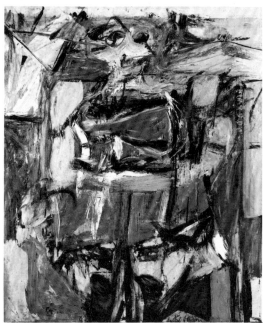

19 Woman VI 1953
Collection Museum of Art,
Carnegie Institute, Pittsburgh

intimate works such as de Kooning's subtly crafted
sketches and studies. Drawing or painting with gestures
(or "actions," as they were sometimes called) became
an almost chauvinistic credo for American art,
even though gestural painting had deep roots in
European Surrealism. Rosenberg's thesis did, however,
have a central virtue: it counteracted excessively
cerebral theories that denigrated the physical aspects
of creation which were central to the surface, if not to
the underlying meaning of de Kooning's work. A
subsequent article by Thomas B. Hess in *Art News,*
"De Kooning Paints a Picture," illustrated and
discussed drawings and oil sketches preparatory to
certain paintings, and also documented the evolution
of painting through its various stages. This analysis
gave credence to the "action" behind de Kooning's
pictures, and demonstrated the importance of process.
At the same time, it showed de Kooning's paintings
arising not from simple "events" but from highly complex
maneuvers in which drawing played a central role.

III

De Kooning's art since 1950 has centered on three
areas of artistic inquiry: the female figure, landscape
and pure abstraction. Often complexly combined,
these three constants come into separate focus at
varying intervals, but always reveal a common origin.
Though the "woman" pictures possess a compelling
iconography, the same mesmeric psychological quality
can be seen in the urban landscapes. By reintroducing
the woman-image into his abstract style, de Kooning
shocked the art world; many proponents of abstraction
felt betrayed that so revolutionary a painter—and one of
their own—could revert to the human figure. It is now
evident that his work always contained the human
presence and always embodied essential paradoxes
and ideological contradictions.

De Kooning's great "woman" paintings of the 1950s,
from *Woman I* (fig. *18*) in The Museum of Modern Art to
Woman VI (fig. *19*) in the Museum of Art at the
Carnegie Institute, were accompanied by a galaxy of
related pastels and charcoal sketches. As a whole,
the "woman" series extended European figuration
at just the moment when some thought (or wished)
it had finally died. The pre-1950 women, such as
Queen of Hearts (fig. *14*) are in the spirit of early

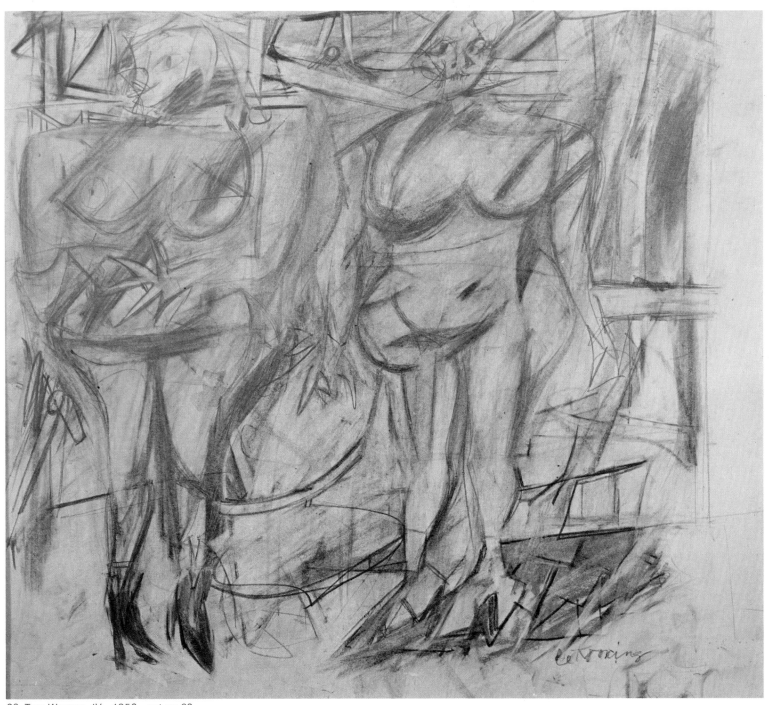

23 *Two Women IV* 1952 cat no 63
Collection William Zierler, New York

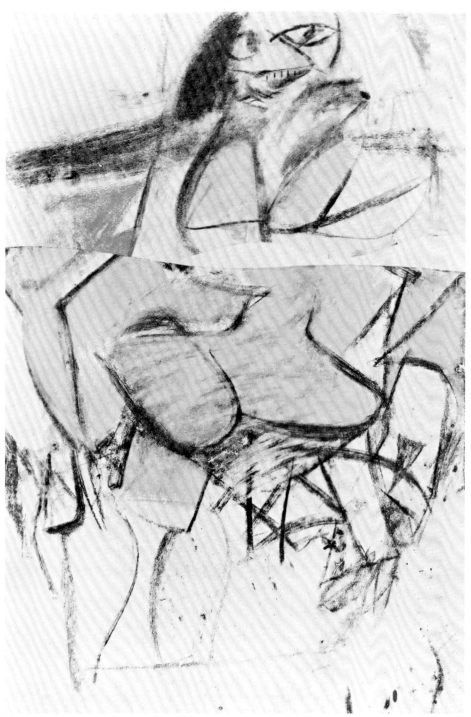

24 *Woman* ca 1952 cat no 69
Collection Musee National d'Art Moderne, Paris

Cezanne still life, the generalized woman-image becomes a "given" in de Kooning's art, allowing the artist to proceed immediately to the essential business of making a picture.

De Kooning's "woman" pastels of the early 1950s (fig. 21) continue a north European attitude toward the figure, shared by such artists as Ensor and the German Expressionists. A curious parallel can be traced between de Kooning's pastel women and Ernst Ludwig Kirchner's pastels of Berlin prostitutes and "tough" show girls produced around 1914 (fig. 20). Kirchner made these studies at a time when the chalks seemed primarily a decorative medium and when full length figure painting was considered a non-issue by the influential Cubist avant-garde. De Kooning's 1950-51 pastels revive this discredited medium with what some of his Abstract Expressionist peers also thought was a reactionary subject. For de Kooning, as for Kirchner a generation earlier, "woman" symbolized the human passions reduced to "art." Its *Schrecklichkeit*, or primitivistic stance becomes a metaphor for aggression and desire.

In de Kooning's "woman" drawings, conventional techniques are ignored for a more immediate handling of chalk and charcoal. Traditional pastel application often calls for a layer by layer application, beginning with the darkest hues and working towards the lightest, with periodic fixing of colors. De Kooning prefers to blur his colors into each other; preliminary outlines in charcoal fuse with paper surface and gray the tonality of the colored chalks. Rubbing and erasing, the artist dematerializes his "woman" images and gives their bodies a luminous sheen. While a similar gash-like stroke builds corporeal forms in his oils, this same gesture, on a smaller scale in the pastels, yields an art of unexpected charm and delicacy.

The ghost-like, hallucinatory images in the "woman" pastels (figs. 41, 42, 54) are an achievement in the medium unsurpassed in mid-century American art, and remind us that human presence is not easily disposed of. For de Kooning, as for Jean Dubuffet and other semi-abstractionists of the 1950s, the iconic figure was as viable a formal starting point for pure painting as the simple rectangle was to the second generation Constructivists. Stylistically, the "woman"

compositions belie the widely held notion that mainstream art in this century has "progressed" in linear fashion, from figurative to abstract; they suggest instead that the history of a great artist's career is sometimes more enlightening than the chronological history of style. The dissembled figure, so crucial to de Kooning's surreal-related abstractions of the late 40s, is reconstituted again in the early 1950s, only to be abstracted again and spread over the surface in his later work.

Discussion about de Kooning's "woman" as the menacing "Bitch Triumphant," an omnipresent theme in north European art from the 1890s to the present, should not disguise the fact that essential differences between the "woman" and her European ancestors are just as instructive as their similarities.
De Kooning's "woman" is a surface image, a shadow to be fleshed out with formal substance. Her eyes are obsessively repeated in breasts, calves, stomach, buttocks and head. Her mouth recurs similarly in each work—the expression varies from that of a man-eating shark to the impassive smile of an archaic statue.
By making this ovoid form of the eye and mouth a common denominator throughout the composition, the figure is absorbed into its surroundings. De Kooning called this interrelatedness of parts in his woman pictures "intimate proportions." Always more interested in the outer shell of "woman" than in its inward psychological qualities, he frequently makes clothes and surrounding objects, rather than major body elements, central to this play of "intimate proportions."

In the pastel *Two Women* (fig. 23), ludicrously pointed shoes, with star-fish like hands to match, are basic generative forms that are multiplied throughout the background: architectural fragments are incorporated within the figures, creating a tightly packed network. Made at the same time as the "woman" paintings, which were thickly built up and declared finished when he decided that he had worked over them enough, the "woman" pastels make a point about reworking. Contours are repeated, corrected, and faint *pentimenti* become integral to the image. This "everything shows" aesthetic is an important aspect of Abstract Expressionism that survives today in contemporary process-oriented art.

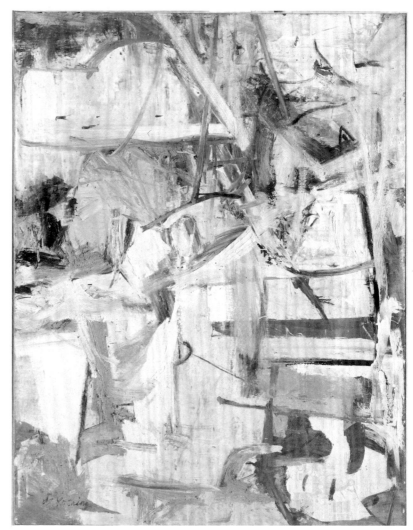

25 *Easter Monday* 1956
Collection The Metropolitan Museum of Art, Rodgers Fund, 1956

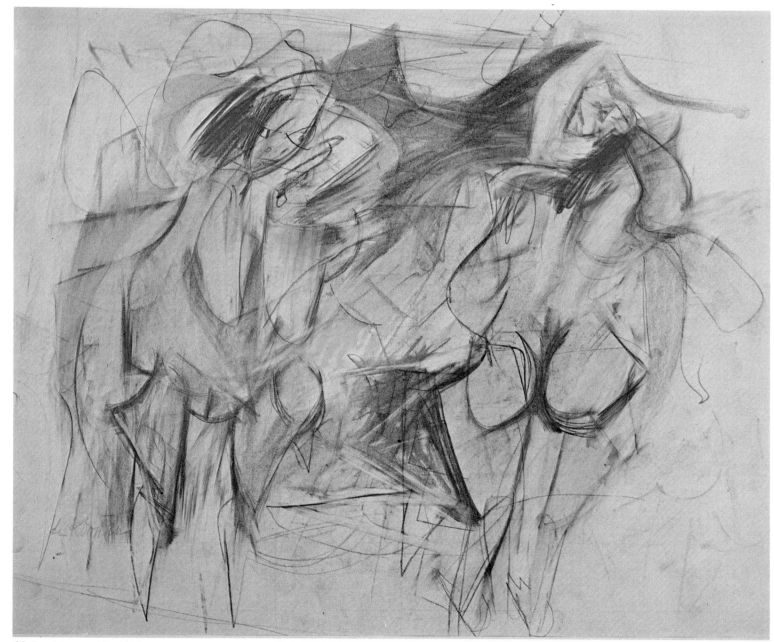

22 Two Women III 1952
Collection Allen Memorial Art Museum, Oberlin College

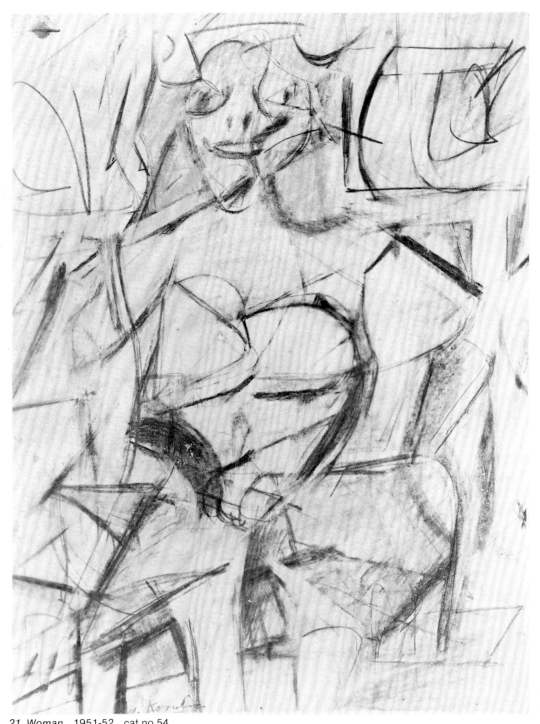

21 Woman 1951-52 cat no 54
Collection Dr. and Mrs. Samuel Mandel, Kings Point, New York

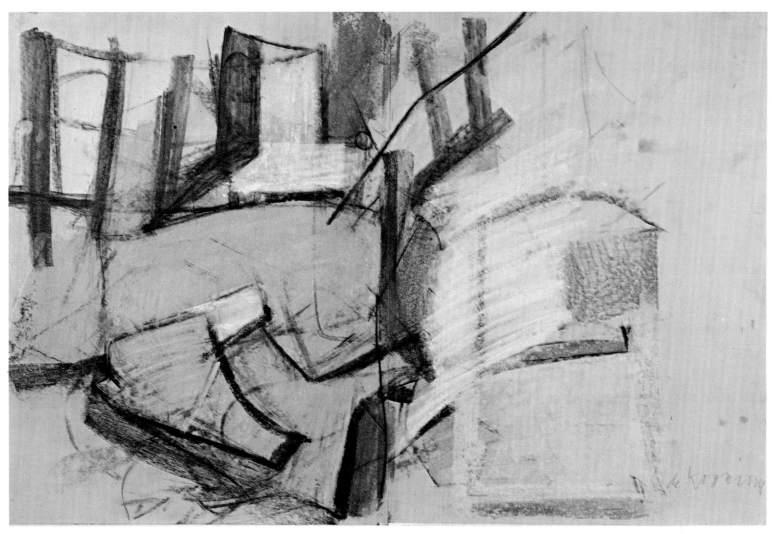

26 *Untitled* 1956-58 cat no 87
Courtesy Fourcade, Droll Inc., New York

A few of de Kooning's "woman" drawings are collages, composite drawings cut apart and reassembled. Using this improvisational approach to composition, the artist drastically compresses and shifts elements of the figure (fig. 24). Heads are pushed off center, necks truncated, and torsos cut short. These collage-drawings provide the link between straight renderings on paper and the oils on whose surfaces the artist fastened sketches in order to position forms. A continuum of media can be seen in the artist's total production in which drawing, collage and painting are regarded as interdependent approaches to making a work.

IV

De Kooning returned to pure abstraction in the late 1950s. Then concerned with large-scale oil painting, the few pastels from this period edge towards all-over surface incident. These now legendary paintings of the 1955-58 period, such as *Easter Monday* in The Metropolitan Museum (fig. 25), were constructed of heroic brushstrokes that became the trademark of his later work, and of 1950s Abstract Expressionism in general. These vigorous paintings are footnoted by a little known series of some fifteen pastels, each a masterful "painting" composition (figs. 26, 46). Even while de Kooning was producing his most explosive gestural works—paintings in which the full swing of the arm came into play (fig. 27)—he continued to make fine scale, meticulous pastels. While Abstract Expressionist rhetoric elevated the act of creation above the object created, these pastels reflect a concern for well crafted, exquisite detail, a sensibility more often tied to European than American draftsmanship.

While in San Francisco and Rome in 1959-60, de Kooning made a series of dramatically graphic black enamel paintings on paper (fig. 29). Later adhered to canvas, these works retain the character of a quick sketch done on a horizontal surface. Some were cut and reassembled as grids along strict horizontal or vertical lines. Their firm, direct calligraphy suggests Kline's influence. Kline worked throughout the 1950s on a series of gestural black-white abstractions (fig. 28), and the relationship of his work to de Kooning's can best be described as methodological. There are also important differences: in contrast to Kline's tensile

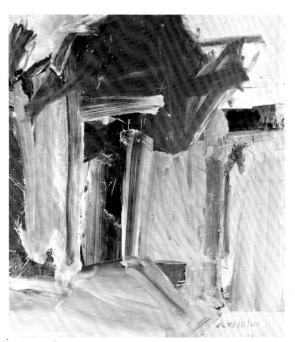

27 *Door to the River* 1960
Collection Whitney Museum of American Art, New York

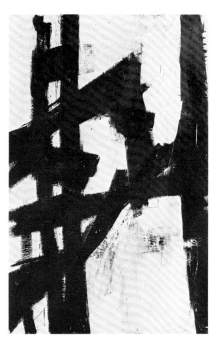

28 Franz Kline *New York* 1953
Collection Albright-Knox Art Gallery, Buffalo

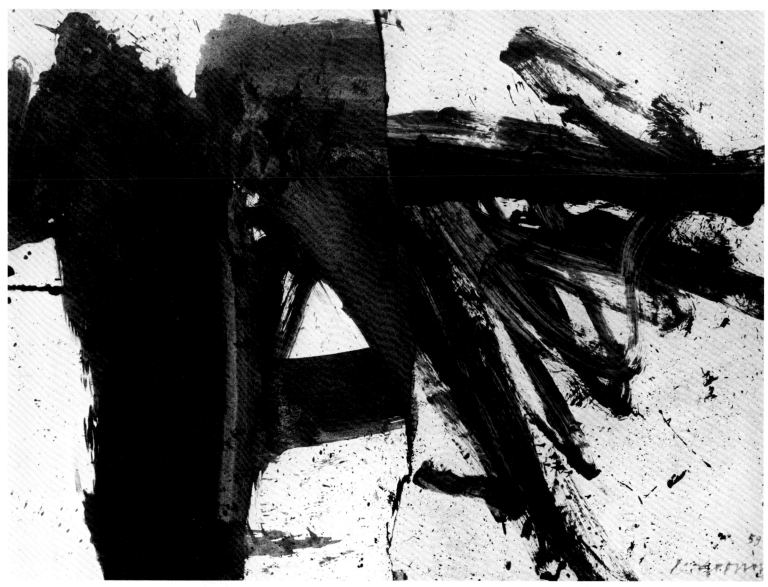

29 *Black and White (Rome)* 1959 cat no 97
Courtesy Fourcade, Droll Inc., New York

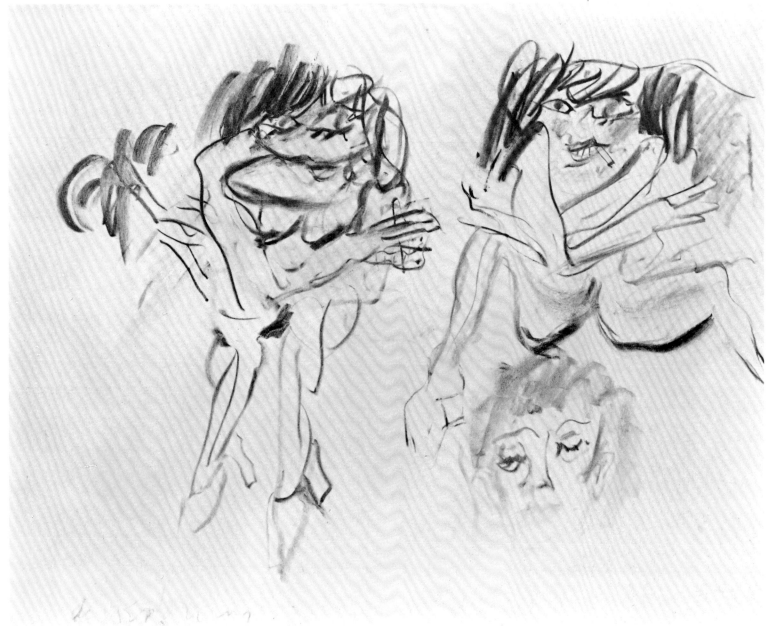

30 *Untitled* 1969 cat no 115
Courtesy Fourcade, Droll Inc., New York

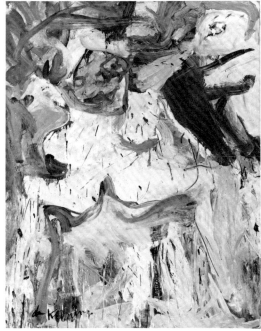

31 *The Visit* 1966-67
Collection The Tate Gallery, London

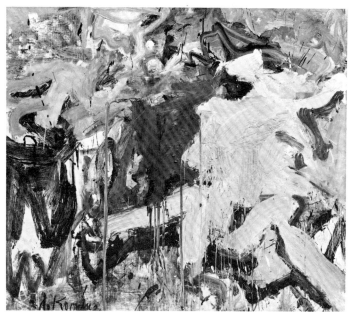

32 *Two Figures in Landscape* 1967
Collection Stedelijk Museum, Amsterdam

architectural forms, de Kooning's work remains organic, and the human figure was never far away from his thinking.

In the 1960s, the nude female reemerged in de Kooning's art, both as woman-in-landscape and as the primordial woman-image (fig. *30*). In this third wave of "woman" pictures there are many flash-backs of earlier work; gradually, around 1965, a newly hybridized figure type takes form. This new figure often appears flattened into a grotesque, boneless, curvilinear form, its arms and legs spread like a squashed toad in the grass. The new woman-in-landscape drawings make explicit the lascivious poses of figures in his contemporary paintings (figs. *31, 32*). Mostly executed in soft charcoal, plant forms and figures inextricably fuse in tangles of lines and smeared shadows; at times, the figure is barely legible, though remarkably little delineation is needed to evoke its presence.

De Kooning says he did some of these later drawings with his eyes closed, with the left hand, or while watching television (figs. *59, 60*). This signaled a reintroduction of so-called "automatic" techniques into the work of a master who had long outgrown Surrealism but still was intrigued by the effects of accident and experiment. He always believed the well planned "accident" could eradicate any left over classical notions about expressing human form. In these high velocity sketches, the artist smears, blots, erases, and smudges the charcoal on the page until an image comes into focus. Though some of these rubbed drawings resemble informal doodles, they are, in fact, constructed of specific graphic units: slashes, squiggles, zigzags and other repeating elements produced by rapid, back and forth movements of the hand.

The most recent group of "woman" charcoal sketches, from 1968-69, raises the point about the essential character of the woman-image in de Kooning's art. In later drawings, the image grows more mocking; it is semi-caricature that invites consideration beyond its formal qualities. It is a witty but powerful psychological quantity. Sometimes the women are insect or plant like, and groups of them emerge from scribbled fields like phantoms in a troubled daydream.

Produced in rapid-fire sessions, these charcoal sketches have a cumulative effect, as if de Kooning were populating his world with a hoard of little people.

The latest drawings in the exhibition record personal observations from two trips, to Charleston, North Carolina and to Spoleto, Italy (fig. 33). Their explicitly autobiographical character—he points out musicians, street scenes, even a Breughel picture in these—is unusual in his work; these drawings represent a desire to incorporate everyday life into the self-confined subject matter of his art. Drawn with ferocious speed, scrawling lines fly in all directions, giving rise to patterns and shapes almost by magic. These sketches testify to the vitality of an artist who has outlived nearly all his Abstract Expressionist peers and who continues to energetically work in several directions at once. At present he is sculpting figures in clay and painting a new series of large abstractions—as always, involved in an impossibly ambitious scheme.

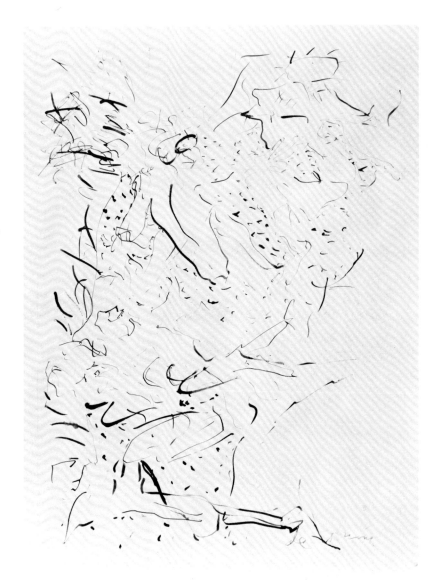

33 *Charleston Pose* ca 1969 cat no 111
Courtesy the artist

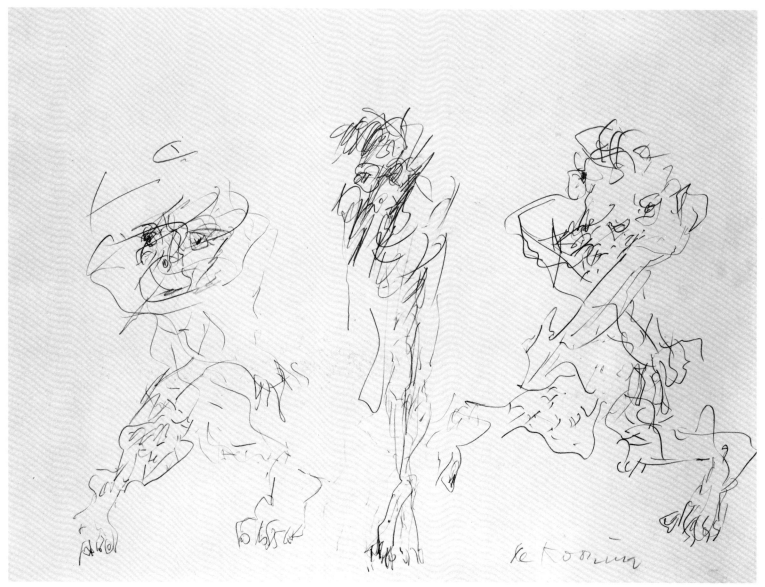

34 Untitled, After Breughel (Spoleto) 1969 cat no 117
Courtesy Fourcade, Droll Inc., New York

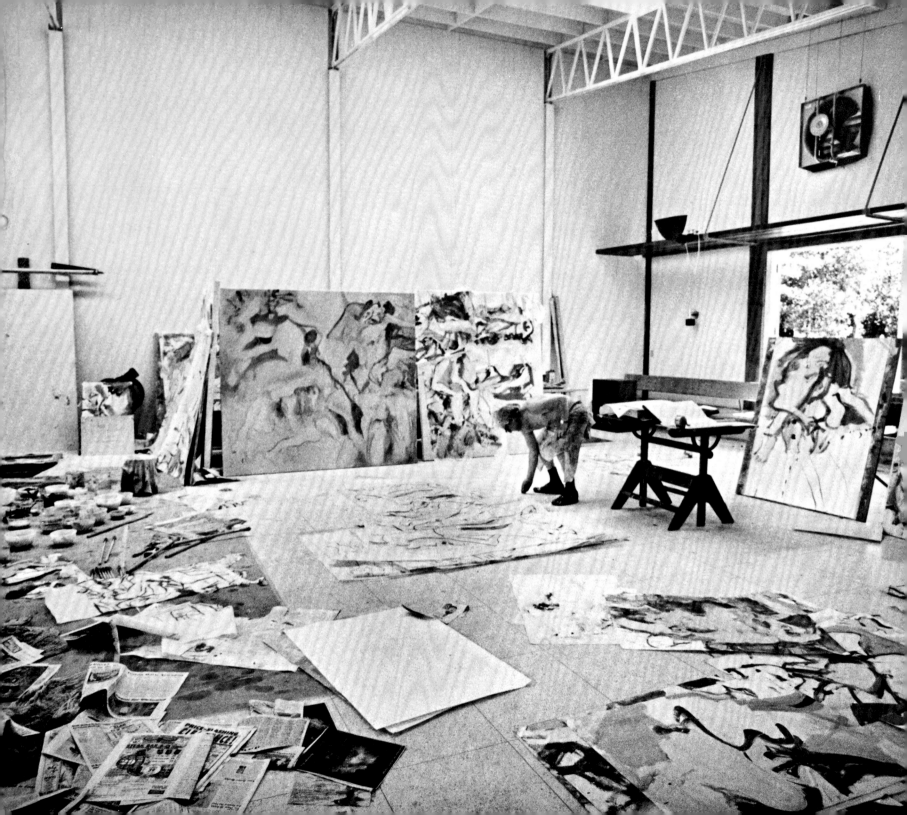

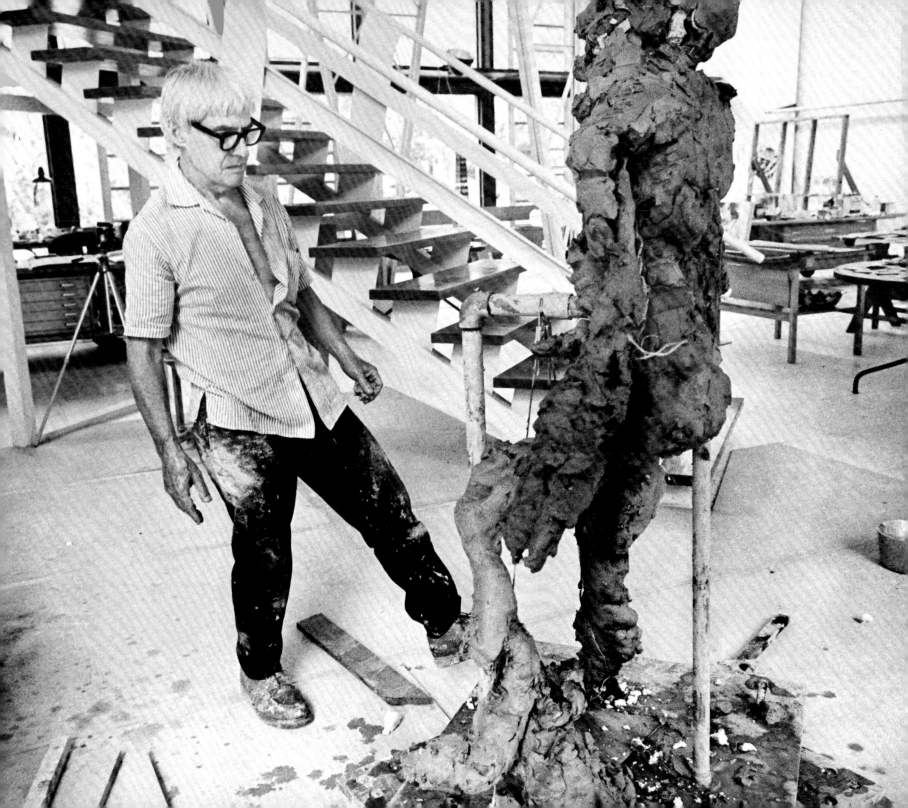

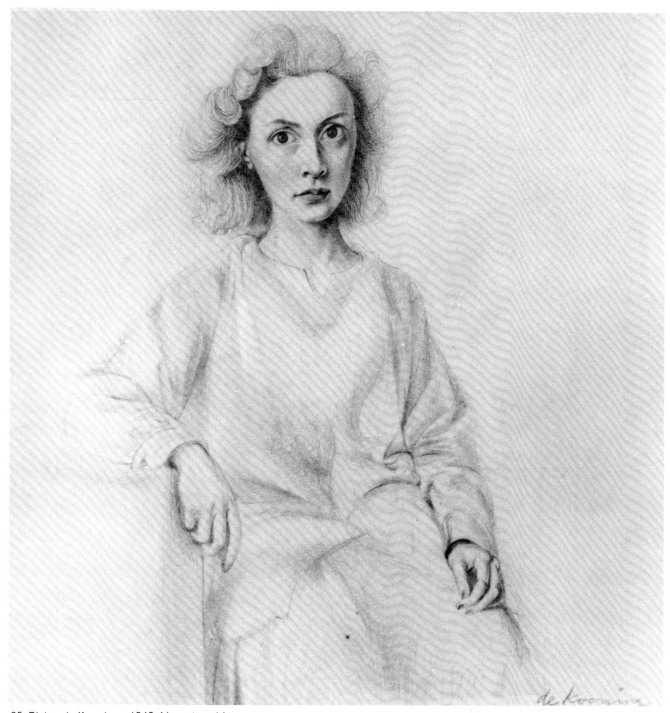

35 *Elaine de Kooning* 1940-41 cat no 14
Courtesy Allan Stone Gallery, New York

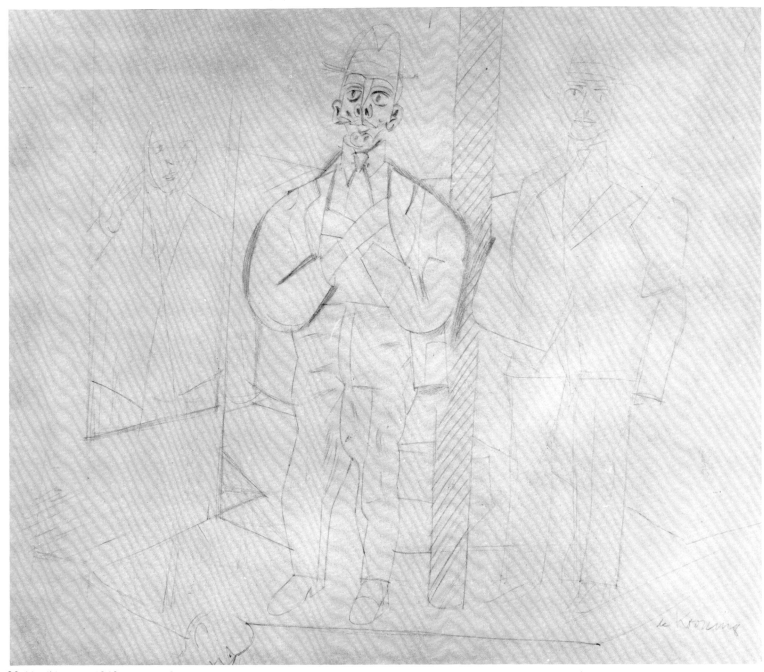

36 *Manikins* ca 1942 cat no 16
 Courtesy the artist

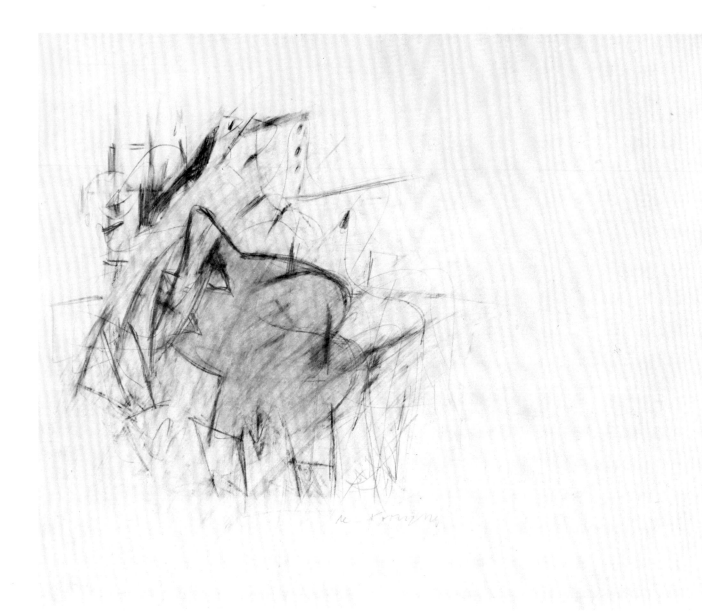

37 *Abstraction* ca 1945 cat no 20
 Courtesy Fourcade, Droll Inc., New York

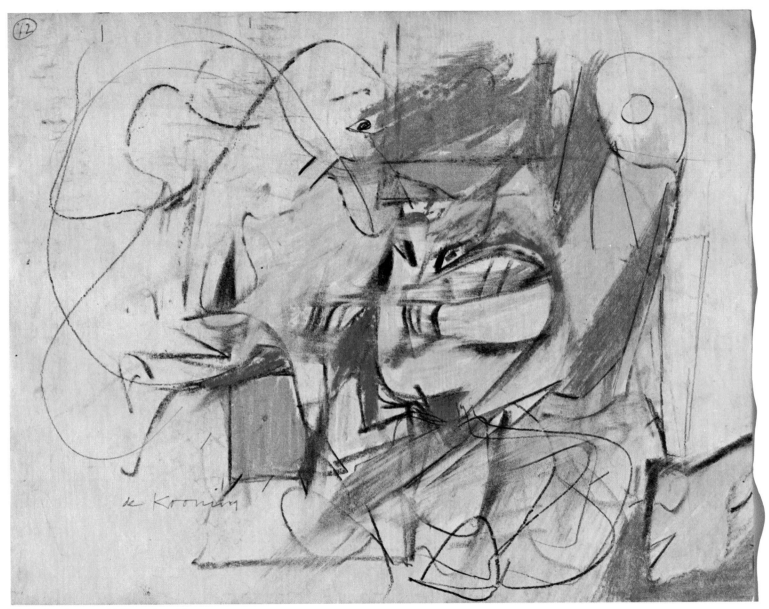

38 *Abstraction* ca 1945 cat no 19
Courtesy Fourcade, Droll Inc., New York

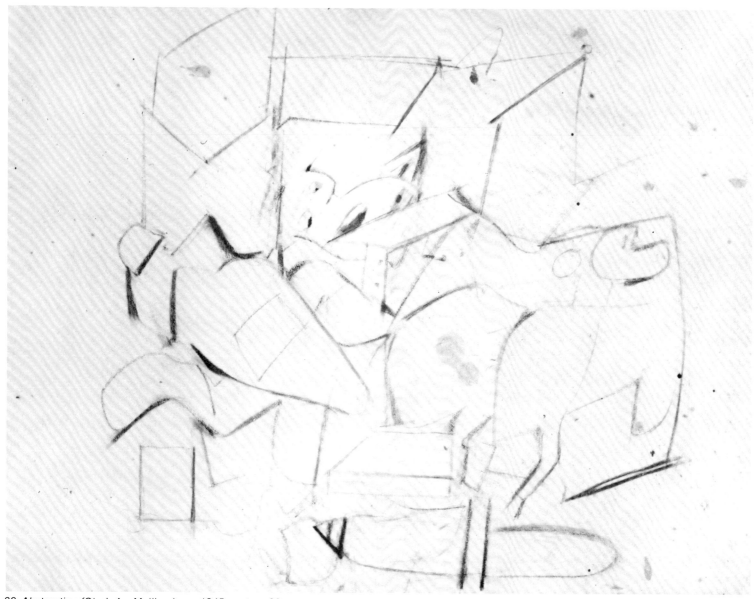

39 *Abstraction (Study for Mailbox)* ca 1945 cat no 22
Courtesy Allan Stone Gallery, New York

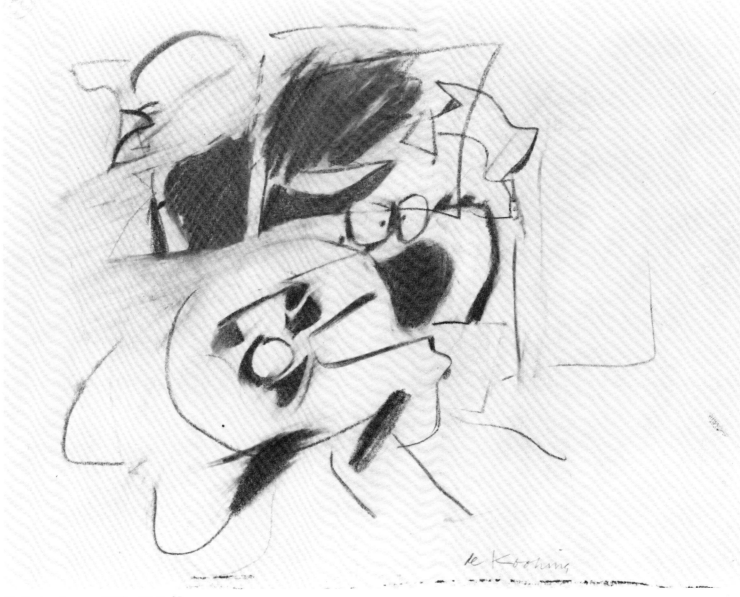

40 *Abstraction* ca 1950 cat no 25
Courtesy Fourcade, Droll Inc., New York

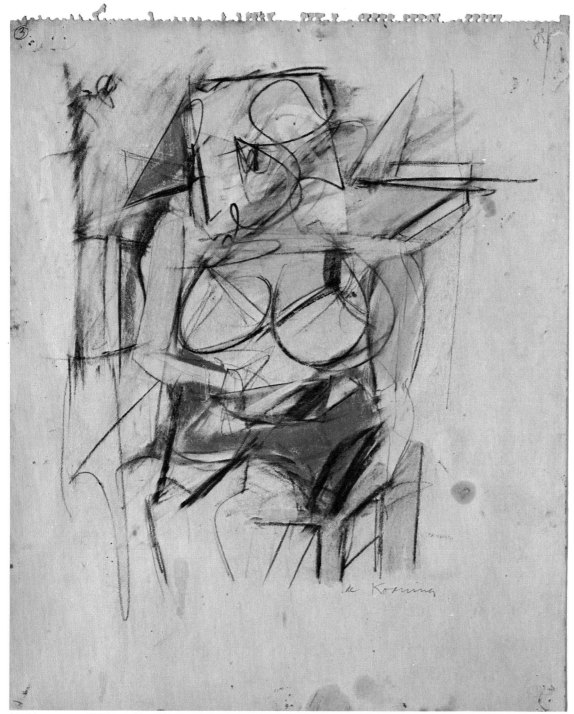

41 *Woman* ca 1952 cat no 64
Courtesy Fourcade, Droll Inc., New York

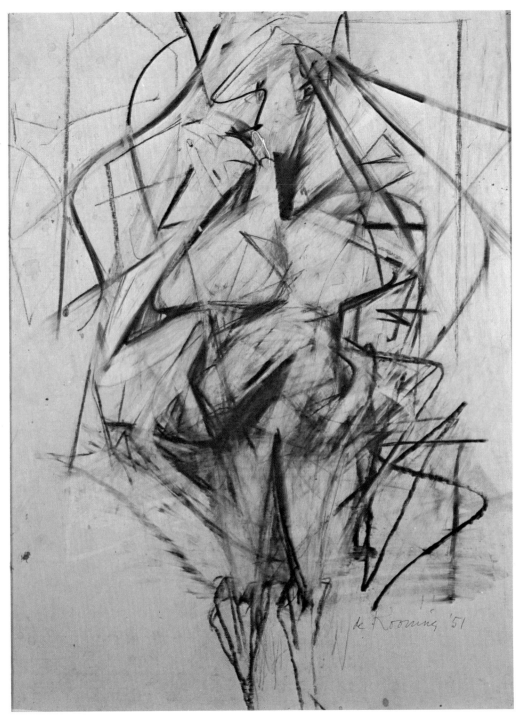

42 Woman 1951 cat no 55
Collection Mr. and Mrs. Paul Tishman, New York

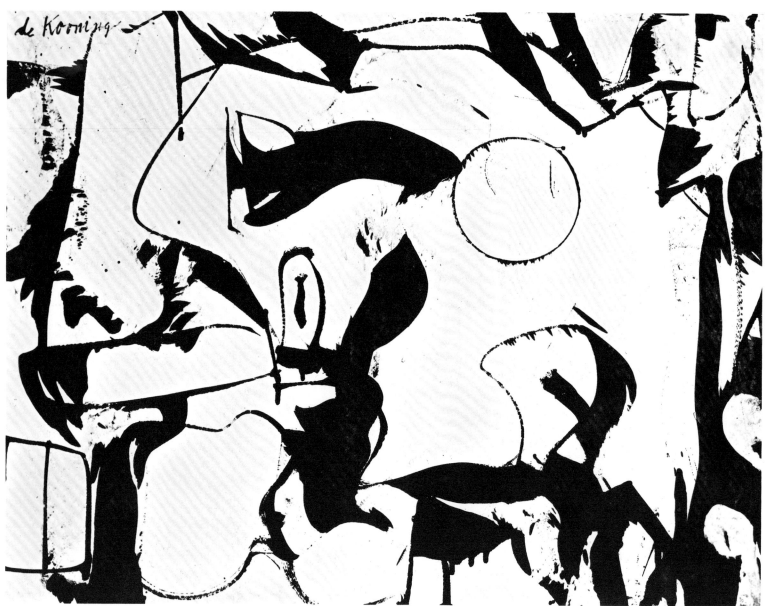

43 *Black and White Abstraction* ca 1950-51 cat no 26
Collection Tamara Jane Safford, Freeport, New York

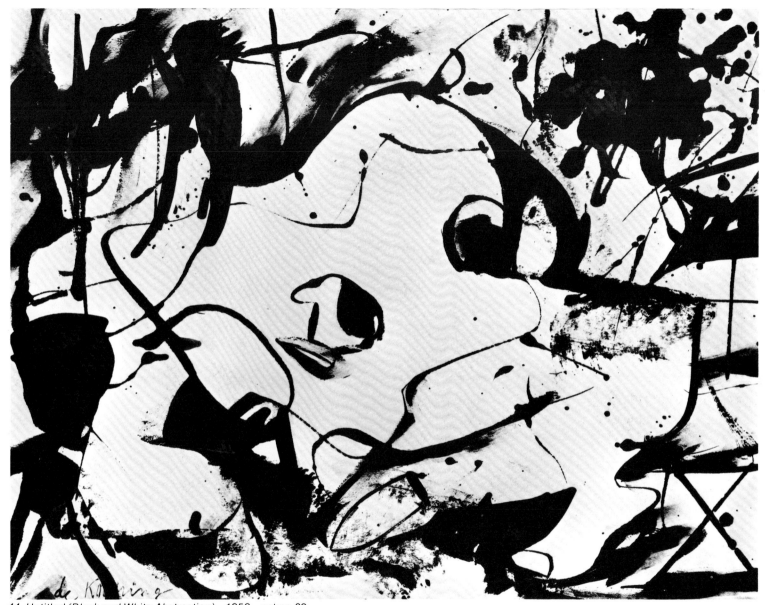

44 Untitled (Black and White Abstraction) 1950 cat no 29
Courtesy Allan Stone Gallery, New York

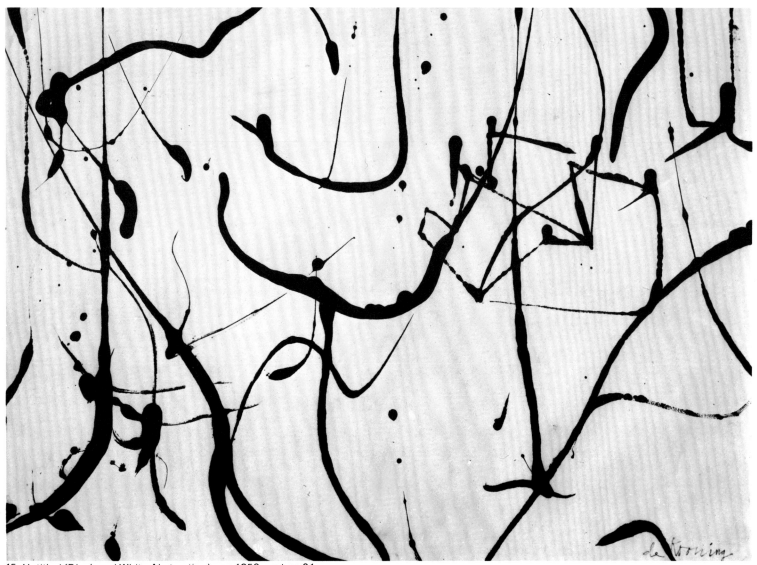

45 *Untitled (Black and White Abstraction)* ca 1950 cat no 31
Collection Mr. and Mrs. Lee Eastman, New York

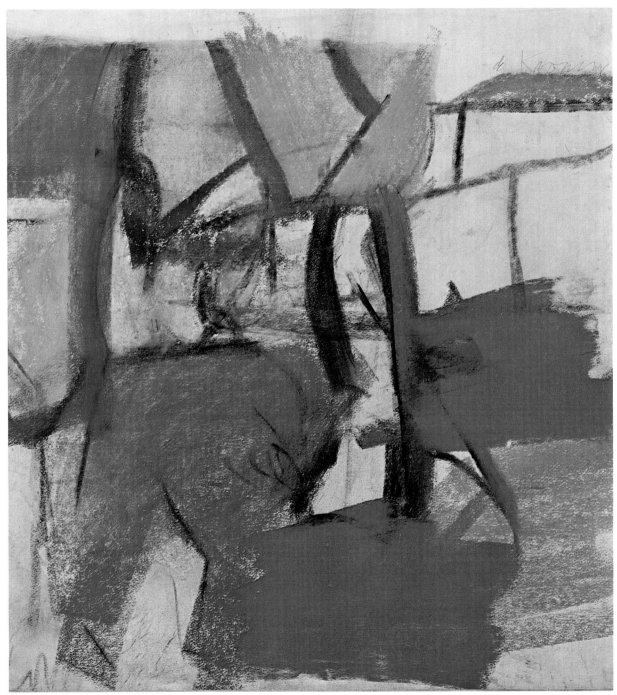

46 Untitled 1956-58 cat no 88
Courtesy Fourcade, Droll Inc., New York

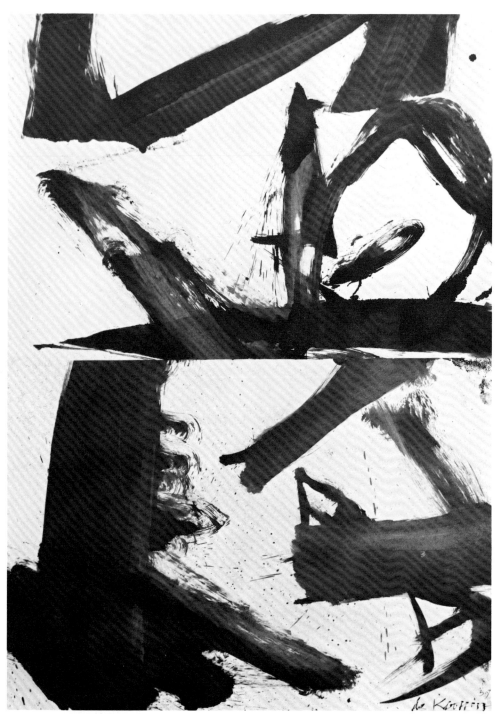

47 *Black and White (Rome)* 1959 cat no 98
Courtesy Fourcade, Droll Inc., New York

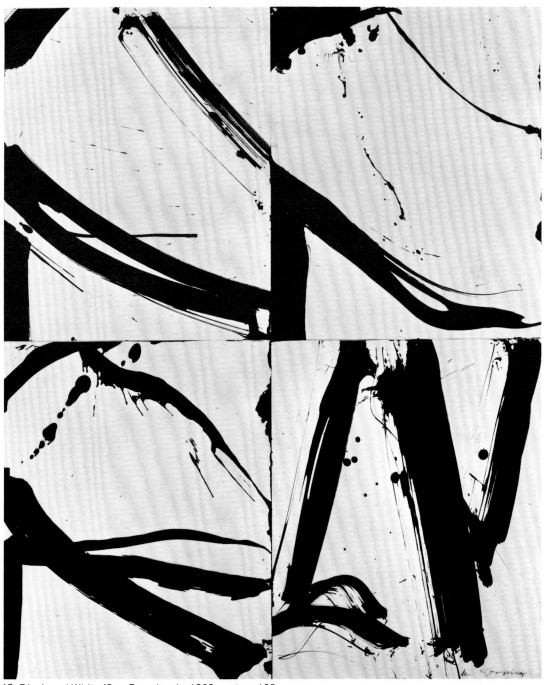

48 *Black and White (San Francisco)* 1960 cat no 100
Private collection, courtesy Fourcade, Droll Inc., New York

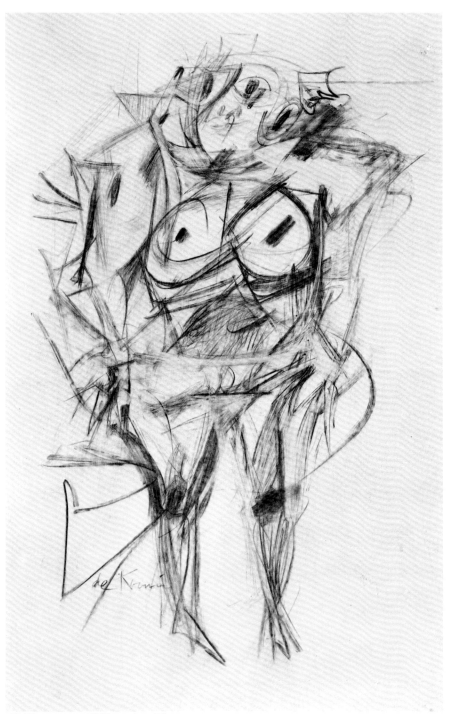

49 *Woman* ca 1953 cat no 74
Collection Mr. and Mrs. Robert C. Scull, New York

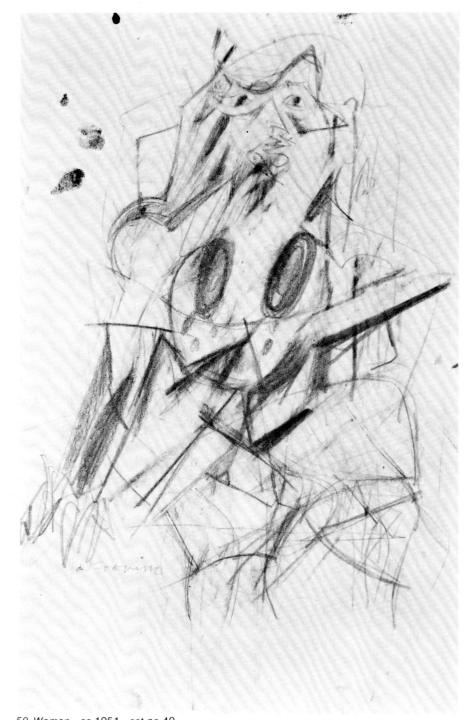

50 *Woman* ca 1951 cat no 49
Courtesy Fourcade, Droll Inc., New York

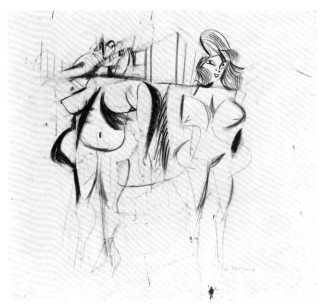

52 *Untitled* ca 1956-58 cat no 84
Courtesy Fourcade, Droll Inc., New York

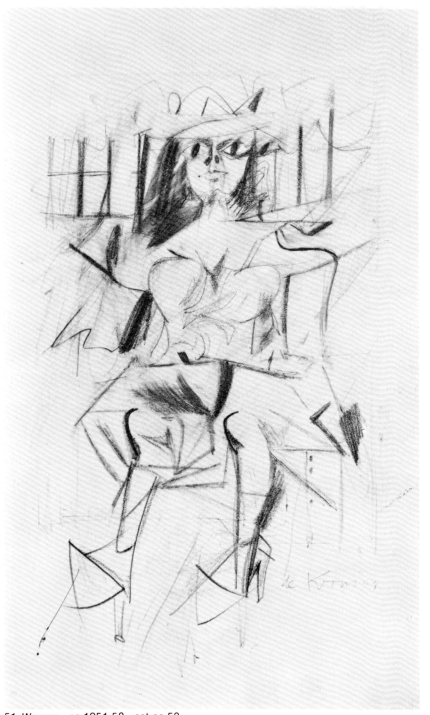

51 *Woman* ca 1951-52 cat no 53
Courtesy Fourcade, Droll Inc., New York

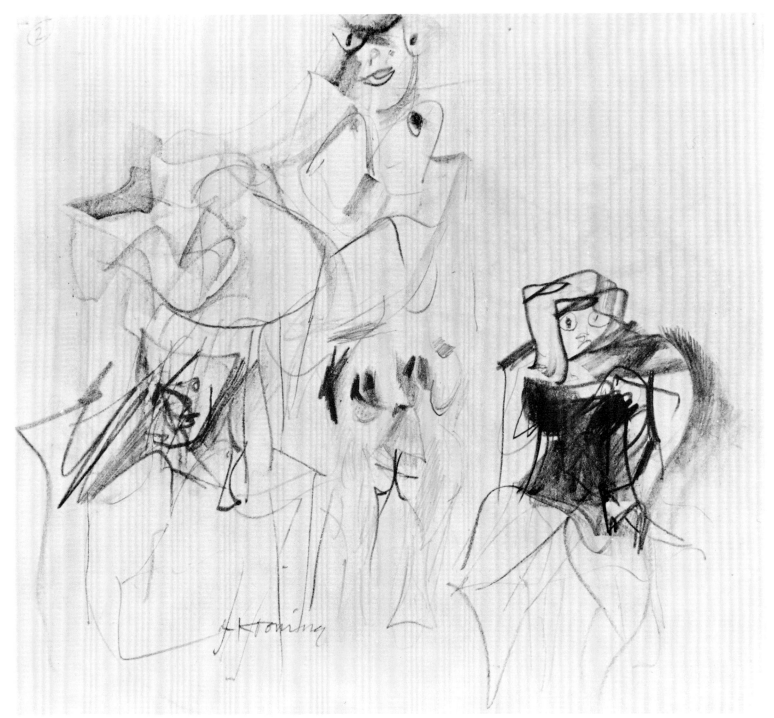

53 *Studies of Women* ca 1954 cat no 77
Courtesy Fourcade, Droll Inc., New York

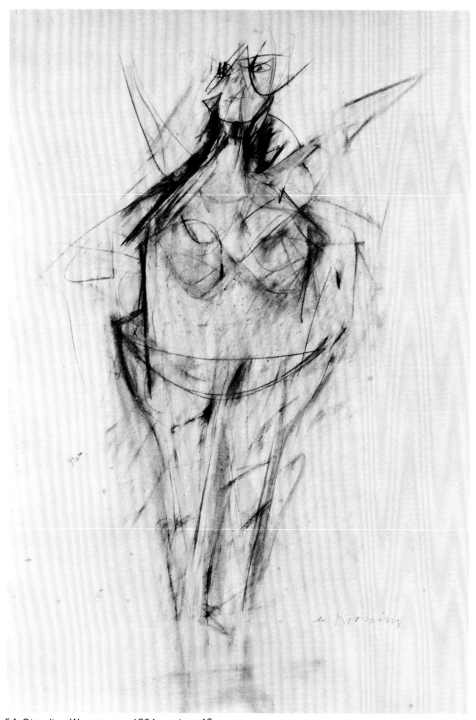

54 Standing Woman ca 1951 cat no 42
Courtesy Fourcade, Droll Inc., New York

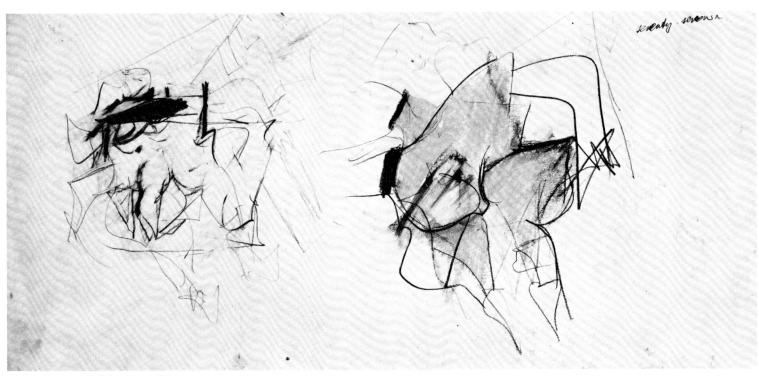

55 *Untitled* ca 1955 cat no 81
Courtesy Fourcade, Droll Inc., New York

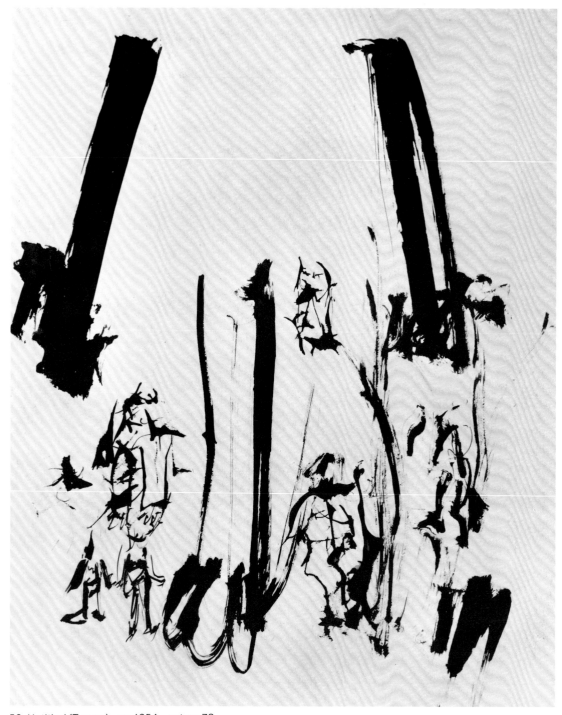

56 *Untitled (Torsos)* ca 1954 cat no 78
Courtesy Fourcade, Droll Inc., New York

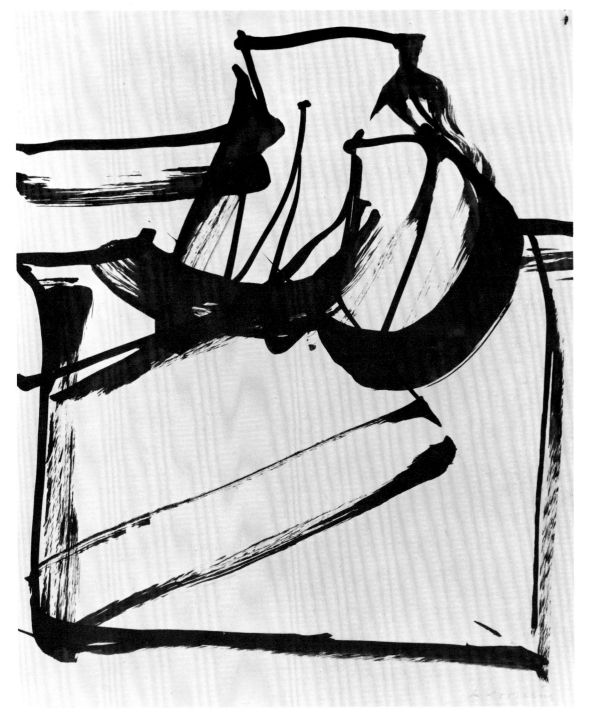

57 Folded Shirt on Laundry Paper 1958 cat no 93
Courtesy the artist

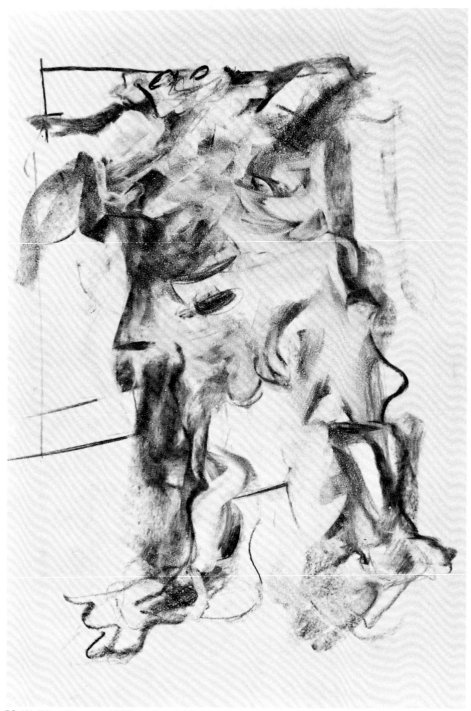

58 *Walking Figure* 1968 cat no 110
Courtesy Fourcade, Droll Inc., New York

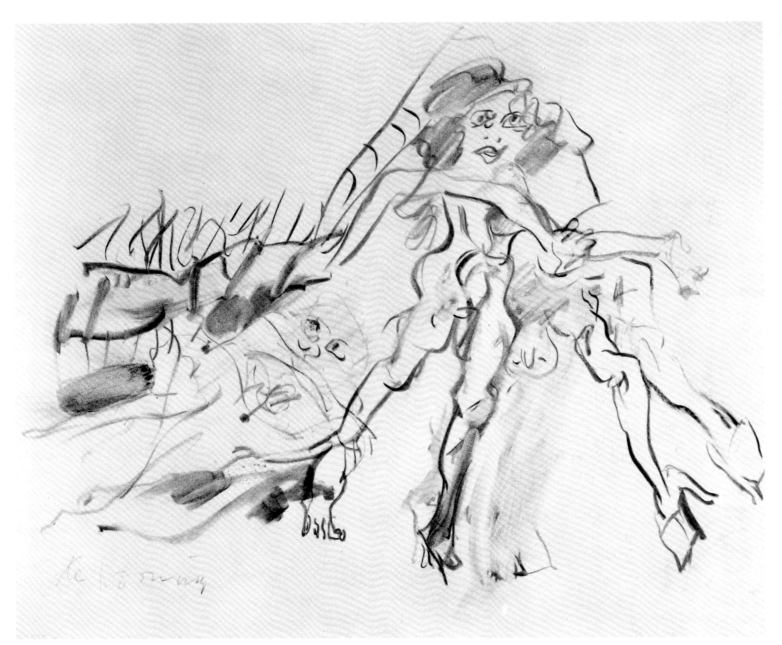

59 *Untitled* 1968 cat no 107
Courtesy Fourcade, Droll Inc., New York

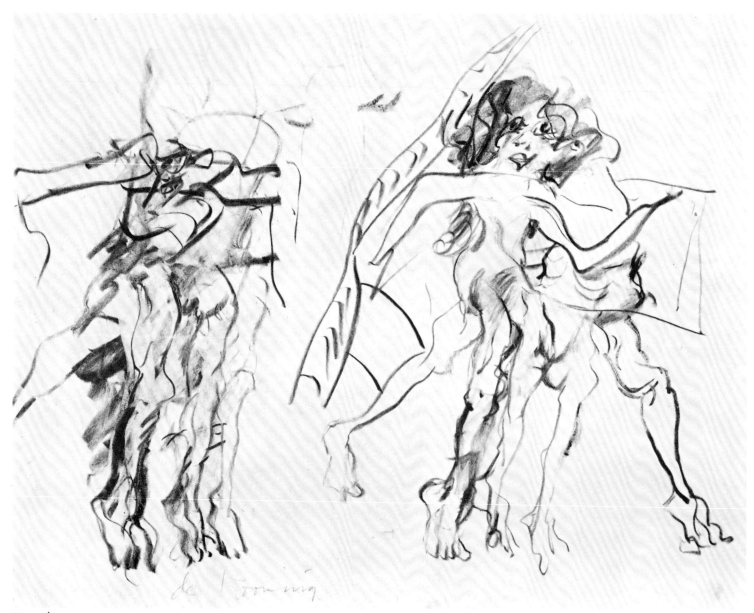

60 Untitled 1969 cat no 116
Courtesy Fourcade, Droll Inc., New York

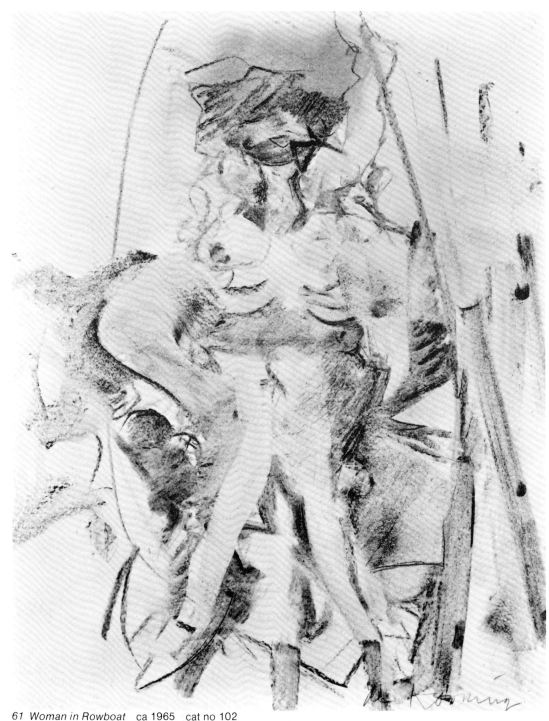

61 Woman in Rowboat ca 1965 cat no 102
Collection Mr. and Mrs. Julius E. Davis, Minneapolis

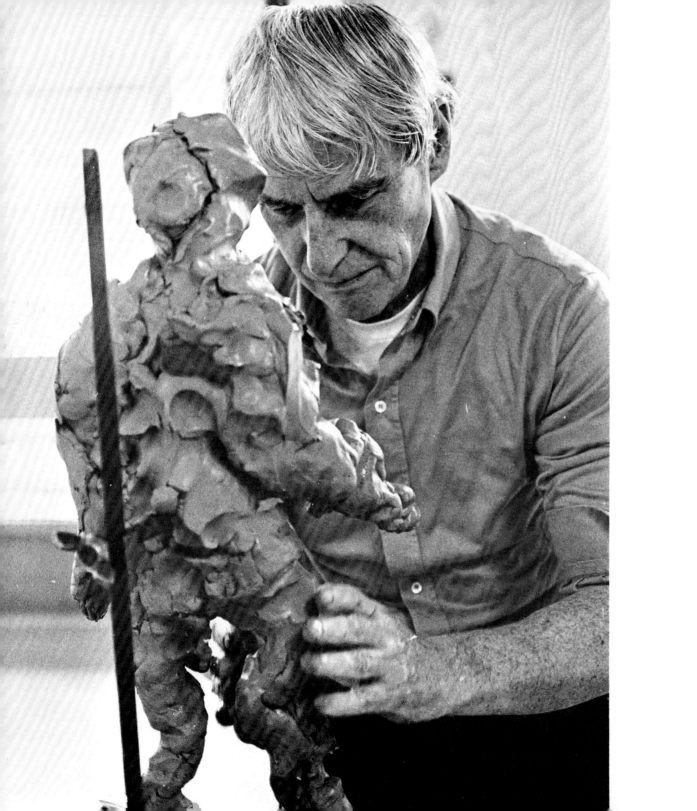

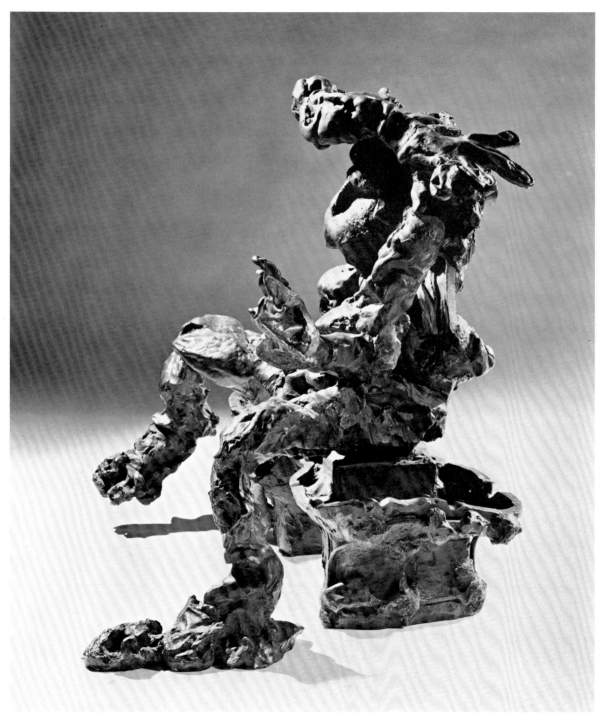

62 Seated Woman on a Bench 1972 cat no 146
Courtesy Fourcade, Droll Inc., New York

De Kooning's Sculpture

by Peter Schjeldahl

I

This exhibition gives the world its first concentrated look at one of the most remarkable developments in recent art: the sculpture of Willem de Kooning. Created in a span of less than five years, these works constitute a startling addition to the artist's own canon and to the history of modern art. Certainly little in his previous work or in the mainstream of modern sculpture could have quite prepared us for them. The example of Matisse, who made some fine figurative bronzes at times throughout his career, comes to mind, but it is hard to think of a precedent for the wit and passion and sheer success with which de Kooning, now 70 years old, has suddenly engaged an unfamiliar medium. In terms of style, these pieces belong to a very exclusive category indeed, that of significant Abstract Expressionist sculpture.

Nearly all the major sculpture of the last 20 years has been entirely abstract, has been put together with a welding torch or a hammer and nails and has given primacy to narrowly aesthetic considerations that its theorists have regarded as the medium's proper concerns. This development was given special impetus by the example of David Smith, whose earlier surrealistic and expressionistic modes were replaced in the mid-1950s by an increasing involvement with Cubist and Constructivist ideas. Repeated attempts by a wide variety of artists to introduce into three dimensions the intimate emotional potency of Abstract Expressionism have met with uneven success. Most of the figurative work in this vein, certainly, has seemed contrived and rhetorical, really effective only when couched in the Pop theatricalism of Segal, Oldenburg and Grooms. The authentic spirit has seemed present in certain abstract works by Barnett Newman (his *Here* series), Reuben Nakian and Mark di Suvero, among a very few others. Even most of these works, however, have proved susceptible to the kinds of formalist understandings lately in vogue.

I apologize for the superficiality of this historical rundown, but it seems important to emphasize de Kooning's virtual isolation from the context of recent avant-garde sculpture. In effect, he has leap-frogged an entire epoch; and, in effect, his nearest contemporary is Giacometti and his nearest major precursor is Rodin. (Gaston Lachaise might be termed a minor precursor.) It is necessary, in seeking an historical appreciation of this work, to adopt a time frame apparently as cockeyed in its contours as the sculptures themselves. De Kooning's audacity, in the face of what now pass for the "issues" of modern sculpture, has been precisely to ignore them. In so doing, however, he has raised at least one other issue that has long been dormant in art discourse. He has raised the issue of artistic sincerity.

The characteristic of his own painting, and of all truly modern expressionistic painting, that de Kooning has incorporated in his sculpture has to do with the artist's "touch," the signature-like quality of his stroke. It might be called an amplification of touch to the point where it is experienced as "gesture," where it takes on a vitality of its own as a direct medium of the artist's personality and, as it were, the hero of the painting. This is where the question of sincerity comes in. Is the gesture in a particular painting a real hero, acting amid real vicissitudes, or only a barroom strutter? The question turns on a consideration of the artist's personal commitment and of the quality of his inner experience as basic artistic values. This is not easy to talk about, for it is a question that gets both asked and answered on an essentially visceral level. Much of modern art, as of modern criticism, often seems calculated to avoid its being raised at all: taste and judgment, not sincerity, are the immediate criteria of a design-oriented art.

De Kooning's taste and judgment are, of course, hardly negligible. He is no primitive. His tightly composed abstractions of the late forties are among the most sophisticated and fecund achievements in 20th-century painting. But in the present show one can see taste and judgment scrambling, so to speak, to accommodate themselves to unpredictable inspirations. Observe, for example, the variety of pedestals and mounts: painted wood, metal slabs, exposed armatures, the sculpted bench of the *Seated Woman on a Bench* (actually only half the bench de Kooning originally made; he decided to discard the

top part) and the odd-shaped bench of the *Seated Woman,* a "found" electrical fixture. Thus as simple and often determinative a matter in sculptural aesthetics as the choice of pedestal has been made to assume a trailing, contingent status.

It is exactly to escape the tyrannies of the intellectual functions, or at least to exclude them from the most crucial moments of creation, that de Kooning has devised many of his creative strategies (a course that probably can be productive only for an artist strong in taste and judgment to begin with—an artist, in this case, who received his early training in the Rotterdam Academy). For instance, the 13 *Little Sculptures* with which he broached the medium were largely executed with his eyes closed. And in the artist's mind while he made them, he has testified, was the idea of a beach scene, a fantasy tableau of which each figure or figure-fragment was one part. One guesses that this rather winsome vision was, in effect, a kind of mental scaffolding, meant from the beginning to be dropped when the goal—a coherent series of small works— was reached.

We may now observe that de Kooning's sincerity takes a particular form, that of an implicit trust in his own unconscious impulses and processes. It is obviously a different thing from that of Rodin, say. Rodin was an artist modern in temperament but with a cast of mind formed by the kind of 19th-century idealism that put its trust above rather than below consciousness. He aimed to bathe his conscious dramatizations of spiritual states in the light of a higher awareness, something in which we have since lost faith. De Kooning's sincerity also differs from that of Giacometti, whose work is an obsessive contemplation of "existential" trauma. Giacometti's figures do not so much occupy space as barely withstand it. They seem eaten away by the light that illuminates them, eroded by an anxiety to avoid falseness that stops just short of eliminating them altogether. De Kooning's mangled but buoyant sculptures may constitute a delayed response to Giacometti's principle of doubt and a part-wistful, part-mocking homage to Rodin.

This kind of speculation can be taken too far, but I think de Kooning's sculpture invites and allows it. As an artist, he is of course not outside history, but the

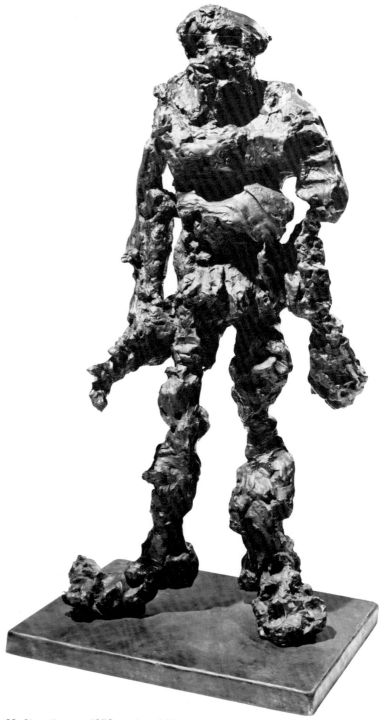

63 *Clamdigger* 1972 cat no 141
Courtesy Fourcade, Droll Inc., New York

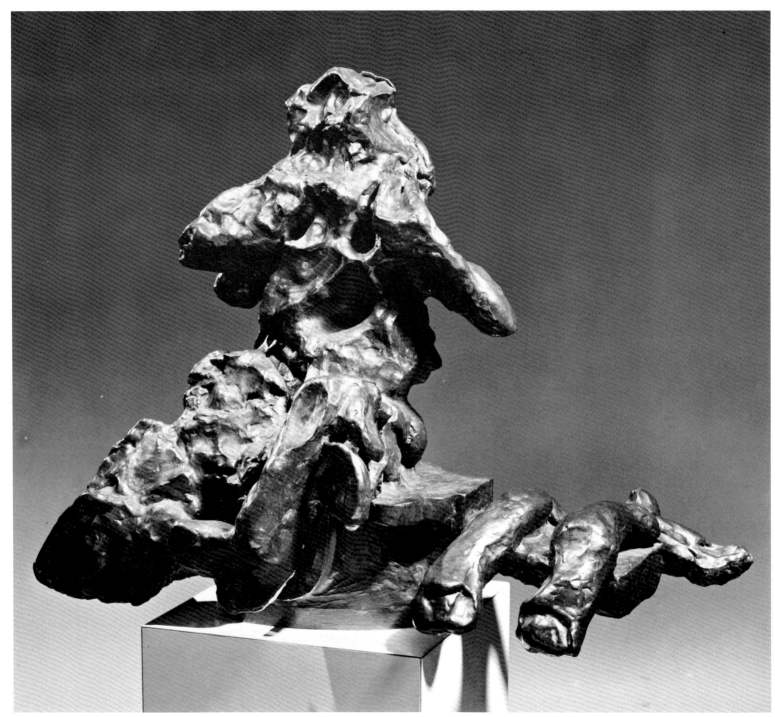

64 Seated Woman 1970 cat no 140
Courtesy Fourcade, Droll Inc., New York

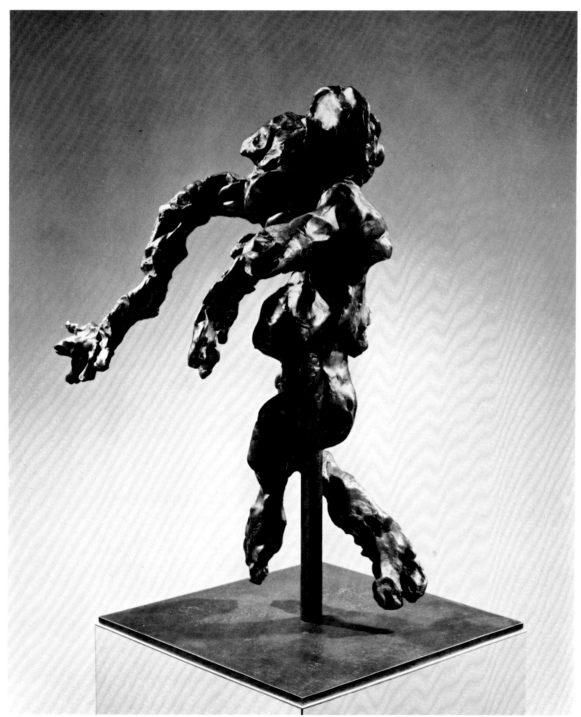

65 *Cross-Legged Figure* 1972 cat no 142
Courtesy Fourcade, Droll Inc., New York

history his work reflects is much more a history of consciousness, of a kind of subjective ranging in time, than one of styles and ideas. This is true of almost all the work of the last 15 years with which he has firmly re-entered, though from a very bizarre and unexpected angle, the Western traditions of figure and landscape painting. What is at issue is not so much a "return to the figure" as an attainment of it, the gradual discovery of an ideally resonant mode for the artist's expression —a mode that may resonate historically and also psychically, with the viewer's own subjectivity. It is difficult, at any rate, to talk about artistic sincerity apart from a figurative art. Perhaps only the presence of mimesis, linking us to the artist by its image of our common humanity, can allow us to consider the question with much assurance.

De Kooning's sculpture profits from being questioned in this way. It convinces. It draws us toward itself, involving us in a set of almost physiological sensations, a complicated response—part discomfort, part exhilaration—to the contorted physiognomies of his figures. There is certainly no question here of "beauty."

The sculptures' proportions are zany, and their surfaces are clotted and dark; they offer few charms to the eye. To be fully experienced, they should be handled. Ultimately it is not the figures themselves that command our attention, but rather the artist's amplified touch, his gesture. It is in this sense that we are justified in calling his work *Abstract* Expressionist, the sense in which a violent gouge across a figure's back becomes more interesting than the figure. We have the figurative basis of the work to hang on and return to, as something reassuring, but the real adventure comes with close perusal. It is an experience of incessant surprise, of mingled giddiness and alarm; what has happened to these joyfully ravaged pieces may happen, as we study them, to some deep image of ourselves.

II

The story of how de Kooning came to make these sculptures is an odd one, rather breathtaking in its fortuity. He made tentative attempts at sculpture earlier in his career, but soon abandoned them. He hated the feel of the clay, he says, and resented the almost

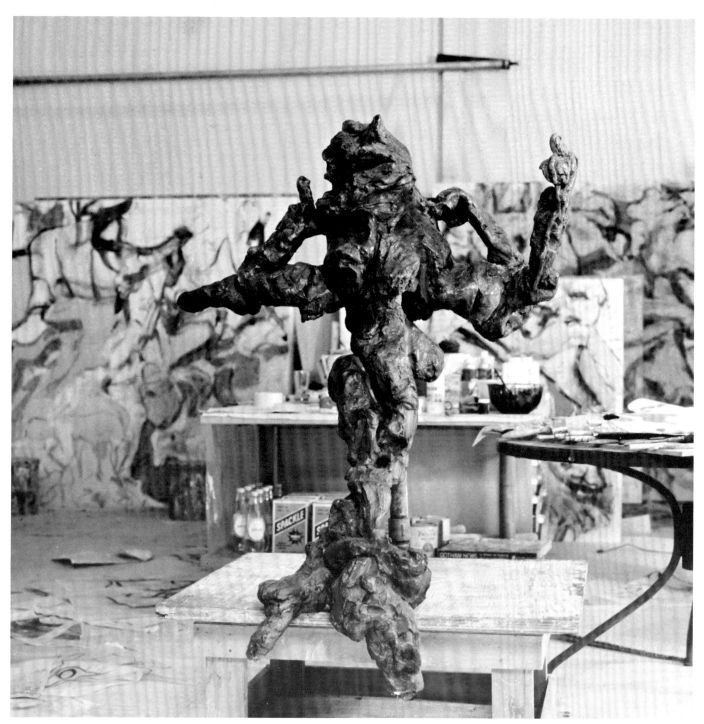

66 *Bar Girl* 1973 cat no 147
Courtesy Fourcade, Droll Inc., New York

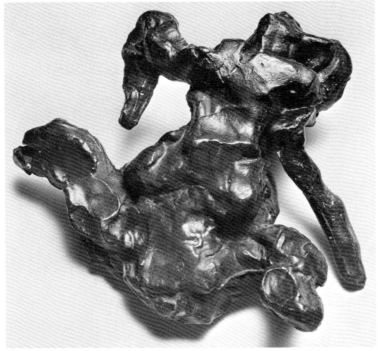

67 *Untitled #1* 1972 cat no 127
Courtesy the artist

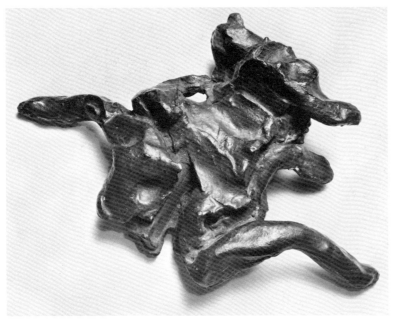

68 *Untitled #2* 1969 cat no 128
Courtesy the artist

perverse independence of the evolving figure, like that of a ventriloquist's dummy with a mind of its own. ("Slap some clay on a sitting figure and, boom, a leaning figure!") The existence of this work owes much to the timely and tactful encouragement of others. The first was Herschel Emmanuel, a sculptor and old friend whom de Kooning, vacationing in the summer of 1969, ran into by chance on a street in Rome. Emmanuel had recently acquired a small bronze-casting foundry outside the city; he invited his friend to pay him a visit there.

The foundry, as de Kooning describes it, was little more than a hole in the ground lined with porous rock; there was one Italian assistant. It was the most low-key operation imaginable. After resisting the idea for a while, he began toying with the clay Emmanuel offered him. He made several objects. Again at Emmanuel's suggestion, they cast a couple of them. De Kooning returned to the foundry many times that summer; at the end of each day, a piece would be selected for completion in bronze. The full set of 13 *Little Sculptures,* each in an edition of six, was finished after he left Rome, and in the spring of 1970 they were shipped to New York. There they rested in the offices of his dealers, Xavier Fourcade and Donald Droll. No one much liked them at first, and de Kooning says he then had no intention of continuing the experiment.

The English sculptor Henry Moore, in New York for an exhibition, cast an influential vote. He was enthusiastic about the small pieces and recommended that they be enlarged, perhaps to monumental proportions. De Kooning consented to have one of the *Little Sculptures* "blown up." The work chosen was the *Seated Woman,* a figure with stubby, wing-like arms and an extra pair of legs, which had been torn off and replaced, arranged beside her. The contours of the piece were so complicated that it proved impossible to reproduce by mechanical means, and much of the work had to be done by hand and eye. De Kooning was so pleased with the result that he hired the young man responsible for it, David Christian, to assist him on a new series of sculptures. From Christian he learned the possibilities of using light polyester resin, which could be given a bronze-like patina, in place of bronze; several of his pieces have been cast in this medium. At the same time,

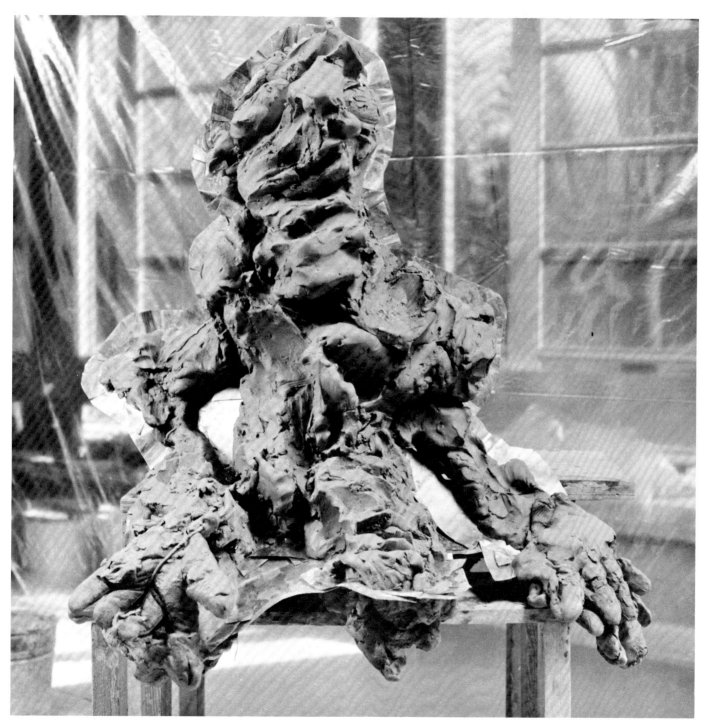

69 Clay model for *Large Torso* 1974 cat no 151
Courtesy Fourcade, Droll Inc., New York

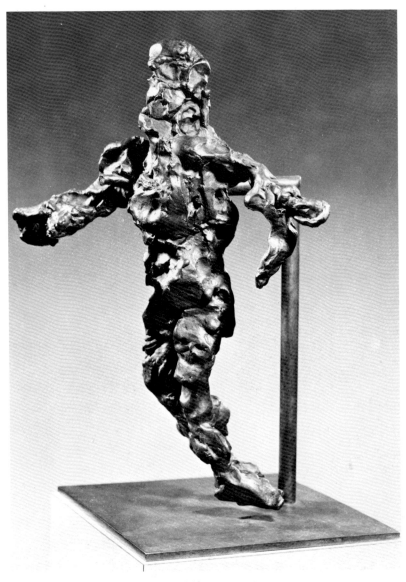

70 *Floating Figure* 1972 cat no 143
Courtesy Fourcade, Droll Inc., New York

rather than continue to bother with the tricky enlarge-
ment process, he decided simply to work large. His first
big piece was the *Clamdigger.*

De Kooning did briefly consider the notion of working
on a monumental scale. One idea that occupied him
for a while, he says, was a 30-foot-high sculpture
roughly modeled on a pair of women's shoes. He may
be kidding, of course, but he does have an informed
and voluble interest in monument-sized sculpture, with
tastes running as much to the old-time academic as to
the modern. He has an especially lively appreciation
of the huge equestrian statue of General Sherman by
Augustus Saint-Gaudens in Central Park. What he
might come up with, given the urge, tantalizes the
imagination. At present, however, he tells of no plans
to make anything larger than life-size.

III

My general remarks about the nature and effect
of de Kooning's sculpture must, for the sake of
balance, be qualified by a discussion of specific works.
For the individual pieces vary quite as much in
emotional identity as they do in formal characteristics.
There is a kind of sibling resemblance among some of
the heads and figures, the sense of a single inspiration
revived from different angles, but others seem more
distantly related. To see this, one need only compare
the agonized *Seated Woman on a Bench*—a headless
figure rocking back, arms raised as if to ward off some
terrifying onslaught—with the savagely ebullient *Bar Girl*
—a loitering figure with three or four arms, upthrust
nose and gash of a mouth emitting an almost audible
whinnying laugh. The former seems an archetypal
embodiment of vulnerability and dread; the latter verges
on social caricature. The handling of the clay—which,
as I've said, is the main thing in de Kooning's sculpture
—is similar in both, but the way we experience it is
obviously affected by what, or even *who,* the figures
seem to be about.

As the artist cheerfully acknowledges, the emotional
character of many of his works is a result of chance—
or, to be more exact, of an "accident" that he has noted
and let stand. This seems particularly likely of the
Little Sculptures, which were, after all, intended as
explorations. *Number II,* for example, has the splayed
legs typical of de Kooning's recent drawings and

paintings of women, but the overall look of the piece suggests nothing so much as a crab. As for *Number IV,* try as I might to discern its subject matter, all I can see is an energized, abstract hunk of bronze, rather like a Henry Moore. In fact, each of these diminutive pieces supplies its own peculiar impression. One looks like a dog, another is wrapped around a Coke bottle and still another bears a metal strip, like a handle for carrying.

Guessing games with serious works of art might seem an irrelevant pastime, except that it is in the nature of de Kooning's art, and also that of perhaps most of the original Abstract Expressionists, to involve viewers in a process of free association. De Kooning may actually be the only important Abstract Expressionist of his generation who has never worked with overtly symbolic motifs or striven, like Pollock and Newman, to evoke some over-arching, cosmic sublime. The ambiguity of his sculpture, certainly, centers closer to home, in the inner world of bodily sensation, the disquiets and confusions of the flesh. Depending on how one looks at them, his figures may cast this world in a mocking or a horrific light. Indeed, some of the *Little Sculptures,* especially, can be viewed in both lights, alternately or even at once. A spirit of playful speculation seems exactly right for approaching these pieces, a way of opening oneself to their effectiveness.

There is little ambiguity as to subject matter in the larger pieces. Here the distortions of normal physical appearance seem charged with specific meaning, or anyway with particular kinds of feeling. Minor pieces like the *Large Head* and the *Round Mask Head* strike one as essentially stylized: amusing virtuoso performances. The distinctly major works—*Clamdigger, Seated Woman on a Bench, Bar Girl* and *Large Torso* —oblige us, by their intensity, to keep our distance. Even the *Bar Girl,* for all her hilarity, has something of the demonic—or angelic—about her, a sense of being possessed by energies quite beyond rational comprehension. On one level she may appear to be an object of ridicule, but on another her laughter boomerangs, taking on a note of hideous triumph. She is the destructive aspect of the Great Mother—the Hindu goddess Kali, perhaps—in modern guise. Working from his unconscious, with a whimsical notion in mind, the artist has here brought forth a primordial

image. It is an image that cannot be experienced or explained in any one way; rather, it must be reckoned with on many levels simultaneously.

A similar air of ambivalence and profundity surrounds the *Clamdigger,* a stolid, glowering figure of Neanderthaloid maleness. De Kooning recounts that the idea for this work came to him while he was bicycling near the beach at Montauk, Long Island. In the distance, lit from behind by a bright sun, he saw men with clamdigging tools standing in the shallows. The hulking torso and spindly limbs of the *Clamdigger* thus reproduce the effect of a figure viewed against a harsh back-light. But this vision does not account for the massive genitals and extremities, which, taken together with the relatively feeble-seeming arms and legs, have a strong symbolic overtone. They suggest a kind of basic incapacity compensated for by a potential for unthinking violence; the *Clamdigger* may be seen as an avatar of dumb rage. But, again, it would be a mistake to think that any single exegesis could exhaust the meanings of an image so rich in content.

What makes all of de Kooning's sculpture so rich—and what must modify all attempts at aesthetic analysis and psychological interpretation—is its strain of zestful, paradoxical humor. This is his equivalent of Rodin's electric sensuality and Giacometti's sly, dark irony, the idiosyncratic accent of the great modern artist. It is the emulsifying agent, so to speak, for many kinds of meaning. We have not been used, for some time, to an art of such challenging fullness, just as we are unaccustomed to taking contemporary figurative bronze sculpture seriously. Nothing, at first glance, could seem more unnecessary than de Kooning's sculpture. Even now, however, these works have begun to create their own necessity through the medium of our experience. We may expect to have more to think, feel and say about them, as they work their slow effects on us, in the coming years.

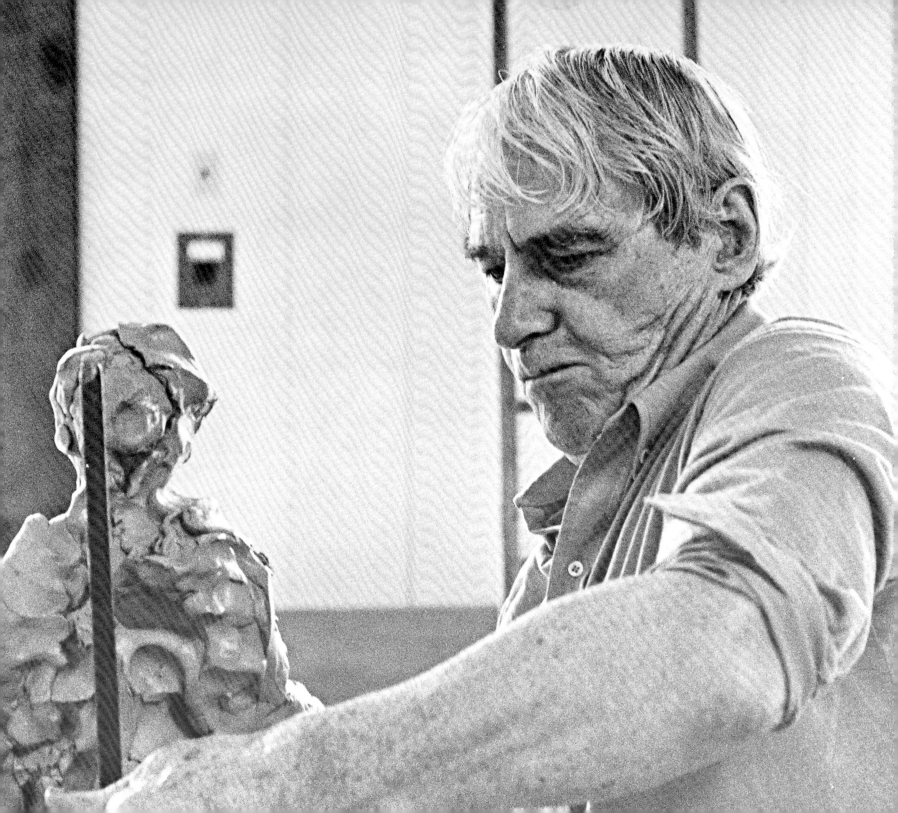

Catalogue of the Exhibition

All dimensions are in inches; height precedes width. For illustrated works see figure numbers (italics) following catalogue entries. An asterisk follows works shown only at Walker Art Center and The National Gallery of Canada.

Drawings

1 *Study for World's Fair Mural "Medicine"* 3
1937 pencil 9 x 12
Courtesy Allan Stone Gallery, New York

2 *Study for World's Fair Mural "Medicine"*
1937 pencil 9 x 10
Courtesy Allan Stone Gallery, New York

3 *Reclining Nude*
ca 1938 pencil 10½ x 13
Courtesy the artist

4 *Seated Man*
ca 1938 pencil 13⅞ x 9
Courtesy Fourcade, Droll Inc., New York

5 *Seated Man*
ca 1938 pencil 13½ x 10½
Courtesy Fourcade, Droll Inc., New York

6 *Seated Man*
ca 1938 pencil 10⅝ x 8⅛
Courtesy Fourcade, Droll Inc., New York

7 *Study for Seated Man*
ca 1938-39 pencil 13⅝ x 10⅜
Courtesy Fourcade, Droll Inc., New York

8 *Study for Seated Man (Self-Portrait)*
ca 1938-39 pencil 13¾ x 11¼
Private collection. New York

9 *Three Studies of Men* 4
ca 1938 pencil 7⅞ x 9⅝
Courtesy Fourcade, Droll Inc., New York

10 *Two Studies of Men*
ca 1938 pencil 13⅜ x 10⅜
Courtesy Fourcade, Droll Inc., New York

11 *Two Studies of Men*
ca 1938 pencil 13⅝ x 10⅜
Courtesy Fourcade, Droll Inc., New York

12 *Studies for Imaginary Men*
ca 1939 pencil 10½ x 12⅝
Private collection, New York

13 *Two Standing Men*
ca 1939 pencil 13¼ x 16¼
Courtesy Fourcade, Droll Inc., New York

14 *Elaine de Kooning* 35
1940-41 pencil 12¼ x 11⅞
Courtesy Allan Stone Gallery, New York

15 *Seated Man*
ca 1940 pencil 13¼ x 11
Courtesy Fourcade, Droll Inc., New York

16 *Manikins* 36
ca 1942 pencil 13½ x 16¼
Courtesy the artist

17 *Seated Woman* 16
ca 1943 pencil 15½ x 12
Courtesy Fourcade, Droll Inc., New York

18 *Abstraction* 7
ca 1945 pencil 18 x 23
Collection Mr. and Mrs. Lee Eastman, New York

19 *Abstraction* 38
ca 1945 pastel, charcoal 8⅜ x 11
Courtesy Fourcade, Droll Inc., New York

20 *Abstraction* 37
ca 1945 pencil, pastel 13 x 18
Courtesy Fourcade, Droll Inc., New York

21 *Abstraction*
ca 1945 pencil, pastel, charcoal 12⅝ x 9½
Courtesy Fourcade, Droll Inc., New York

22 *Abstraction (Study for Mailbox)* 39
1945 pencil 9 x 12
Courtesy Allan Stone Gallery, New York

23 *Abstraction (Study for Pink Angels)*
1945 pastel, pencil 12 x 13⅞
Courtesy Allan Stone Gallery, New York

24 *Woman*
ca 1945 pencil, gouache 12⅝ x 9⅝
Courtesy Fourcade, Droll Inc., New York

25 *Abstraction* 40
ca 1950 pencil, charcoal 8⅜ x 11
Courtesy Fourcade, Droll Inc., New York

26 *Black and White Abstraction* 43
ca 1950-51 Sapolin enamel 23 x 31
Collection Tamara Jane Safford, Freeport, New York

27 *Florida Trailer*
1950-51 Sapolin enamel 22 x 30
Courtesy Sidney Janis Gallery, New York

28 *Untitled*
1950 oil 18½ x 25⅛
Collection Hirshhorn Museum and Sculpture Garden, Smithsonian Institution, Washington, D. C.

29 *Untitled (Black and White Abstraction)* 44
1950 Sapolin enamel 23½ x 21¼
Courtesy Allan Stone Gallery, New York

30 *Untitled (Black and White Abstraction)*
1950 Sapolin enamel 21¼ x 23½
Courtesy Allan Stone Gallery, New York

31 *Untitled (Black and White Abstraction)* 45
ca 1950 Sapolin enamel 21½ x 29½
Collection Mr. and Mrs. Lee Eastman, New York

32 *Untitled (Black and White Abstraction)* 13
1950 Sapolin enamel 22 x 30
Collection William Zierler, New York

33 *Reclining Women*
ca 1950 pencil 10¼ x 13¾
Private collection, courtesy Fourcade, Droll Inc., New York

34 *Two Women*
1950 pencil 8 x 8⅛
Private collection, courtesy Fourcade, Droll Inc., New York

35 *Untitled*
ca 1950 pencil 8⅜ x 11
Courtesy Fourcade, Droll Inc., New York

36 *Untitled (Crucifixion)*
1950 pencil 13⅞ x 17
Courtesy Fourcade, Droll Inc., New York

37 *Woman* 17
1950 pencil 11⅝ x 3⅞
Private collection, courtesy Fourcade, Droll Inc., New York

38 *Black and White Abstraction*
1951 Sapolin enamel 24¼ x 30¼
Collection Museum of Art, Munson-Williams-Proctor Institute, New York

39 *Itinerant Chapel*
1951 Sapolin enamel 22 x 30
Collection Mr. and Mrs. B. H. Friedman, New York

Willem de Kooning

Chronology

1904 Born in Rotterdam.

1916-25 Studied at various times at the Rotterdam
 Academy of Fine Arts and Techniques.
 Became familiar with paintings of *de Stijl*,
 the modern School of Paris masters and
 Jan Toroop's decorative work.

1927 Moved to New York, where he worked
 as a house painter and commercial artist.
 Met John Graham, Arshile Gorky and
 Stuart Davis.

1935 Became a full-time painter.
 Worked on several W.P.A. mural projects
 in New York.
 Influenced by surreal art, especially that
 of Picasso and Miró.

1937 Provided design for the Hall of Pharmacy,
 New York World's Fair.
 Executed drawings and paintings of figures
 in interiors and still life compositions in
 schematic surreal-influenced style.
 Shared studio with Gorky.

1938 Began first "woman" series, which
 culminated in the 1944 *Pink Lady*.

1942 First public showing in a group show at
 McMillan, Inc., New York.

1945 Began surreal abstractions with *Pink Angels*.

1946 Began *Black and White Abstraction* series
 of oil paintings which were shown in first
 one-man show at Egan Gallery, New York.

1950 Culminated his abstract-surreal style with
 Excavation which won first prize at
 The Art Institute of Chicago's annual
 exhibition and was shown in the 1951
 Venice Biennale.
 Executed the *Black and White Abstraction*
 series of enamel drawings.
 Started to work on *Woman I*.

1951-52 Executed the "woman" and "two women"
 pastels and a series of monumental
 "woman" paintings.

1957 Began series of abstract urban landscapes
 executed with expansive gestures.

1959-60 Traveled to Rome and San Francisco where he executed black brush drawings.

1963 Moved to Easthampton, Long Island and built large studio.
Began "woman in landscape" series.

1969 Traveled again to Rome where he cast his first sculptures.
Traveled to Japan.

1970-71 Executed series of black-white lithographs. Began to work on figurative life-size sculptures.

1973 Began new series of abstract oil paintings.

One-Man Shows of Drawings, Sculptures

1953 Sidney Janis Gallery, New York, *Willem de Kooning*

1956 Sidney Janis Gallery, *Willem de Kooning*

1964 Allan Stone Gallery, New York, *De Kooning Retrospective Drawings 1936-1963*
James Goodman Gallery, Buffalo, *"Woman" Drawings by Willem de Kooning*

1966 Allan Stone Gallery, *De Kooning's Women* University of Texas, Austin, *Drawings &*

1969 Knoedler and Company, New York, *De Kooning January '68—March '69*
The Museum of Modern Art, New York, *Willem de Kooning*

1971 Knoedler and Company, *De Kooning Lithographs*

1972 Sidney Janis Gallery, *An Exhibition by de Kooning Introducing His Sculpture and New Paintings and Pastels*

Bibliography

This selected bibliography deals with de Kooning's drawings and sculptures.

Statements and Interviews

"Artists' Sessions at Studio 35 (1950)," in Motherwell, Robert and Reinhardt, Ad (eds.) *Modern Artists in America,* New York: Wittenborn, 1950

"The Renaissance and Order," *Trans/formation,* vol. 1, no. 2, 1951, pp. 85-87

"What Abstract Art Means to Me," *The Museum of Modern Art Bulletin,* vol. 18, no. 3, Spring 1951, pp. 4-8

"Is Today's Artist With or Against the Past?" (with Thomas B. Hess), *Art News,* June 1958, p. 27

"Content is a Glimpse…" (with David Sylvester), *Location,* Spring 1963, pp. 45-53

De Kooning Drawings, New York: Walker, 1967, brief statement by the artist

"A Desperate View," talk delivered at "The Subjects of the Artist," A New School, New York, February 18, 1949, published in Thomas B. Hess, *Willem de Kooning,* New York: The Museum of Modern Art, 1969, pp. 15-16

"Interview with Willem de Kooning" (with Harold Rosenberg), *Art News,* September 1972, pp. 54-59

Exhibition Catalogues and Monographs

Ashton, Dore, *Willem de Kooning.* Smith College Museum of Art, Northampton, Massachusetts, 1965

Drudi, Gabriella, *Willem de Kooning.* Milan: Fabri, 1972

Greenberg, Clement, *De Kooning Retrospective.* Boston Museum School, Boston, Massachusetts, 1953

Hess, Thomas B., *Willem de Kooning* ("The Great American Artist Series"). New York: George Braziller, 1959

_____, *De Kooning: Recent Paintings.* New York: Walker, 1967

_____, *Willem de Kooning.* New York: The Museum of Modern Art, 1969

_____, *Willem de Kooning Drawings.* Greenwich, Connecticut: New York Graphic Society Ltd., 1972

Inge, William, *Willem de Kooning.* Paul Kantor Gallery, Beverly Hills, California, 1965

Janis, Harriet and Blesh, Rudi, *De Kooning.* New York: Grove Press and London: Evergreen Books, 1960

Odets, Clifford, *Willem de Kooning.* Paul Kantor Gallery, 1961

Articles and Reviews

Ashberry, John. "Willem de Kooning Lithographs," *Painterly Painting, Art News Annual XXXVII,* October 1971, pp. 117-128

Ashton, Dore. "Abstract Expressionists and Imagists, an Important Exhibition at the Guggennheim," *Arts and Architecture,* December 1961, p. 45

_____. "New York Commentary: de Kooning's Verve." *Studio,* June 1962, pp. 216-217.

Barr, Alfred H., Jr., "7 Americans Open in Venice. De Kooning," *Art News,* June 1950, pp. 22-23, 60

Hess, Thomas B. "De Kooning Paints a Picture," *Art News,* April 1951, pp. 30-33

_____. "Willem de Kooning," *Art News,* March 1962, pp. 40-51, 60-61

_____. "De Kooning's New Women," *Art News,* March 1965, pp. 36-38, 63-65

Kozloff, Max. "The Impact of de Kooning," *Arts Yearbook 7,* 1964, pp. 77-88

Kramer, Hilton. "A Career Divided," *New York Times,* March 9, 1969

_____. "De Kooning Survey Opens at the Modern," *New York Times,* March 5, 1969, p. 36

Rosenberg, Harold. "Art of Bad Conscience," *New Yorker,* December 16, 1967, pp. 138-149

Sawyer, Kenneth B. "Three Phases of Willem de Kooning," *Art News and Review,* November 22, 1958, pp. 4-16

Schjeldahl, Peter. "New York Letter," *Art International,* October 1969, p. 74

_____. "Willem de Kooning: Even His 'Wrong' is Beautiful," *New York Times,* January 9, 1972, p. 23

_____. "De Kooning: Subtle Renewals," *Art News,* November 1972, pp. 21-23

Sylvester, David. "De Kooning's Women," *The Sunday Times Magazine,* London, December 8, 1968, pp. 44-49